· ART DECO ·
TULSA

SUZANNE FITZGERALD WALLIS

PHOTOGRAPHY BY SAM JOYNER | FOREWORD BY MICHAEL WALLIS

Published by The History Press
Charleston, SC
www.historypress.com

Copyright © 2018 by Suzanne Fitzgerald Wallis
All rights reserved

First published 2018

Manufactured in the United States

ISBN 9781625859891

Library of Congress Control Number: 2017963911

Notice: The information in this book is true and complete to the best of our knowledge. It is offered without guarantee on the part of the author or The History Press. The author and The History Press disclaim all liability in connection with the use of this book.

All rights reserved. No part of this book may be reproduced or transmitted in any form whatsoever without prior written permission from the publisher except in the case of brief quotations embodied in critical articles and reviews.

To Michael Wallis
My life partner, whose inspiration, encouragement and love are constant.

To Keith Fitzgerald
My brother, whose architectural and artistic talent has been my guide.

CONTENTS

Foreword. Living on Tulsa Time, by Michael Wallis	7
Acknowledgments	15
PART I. MAGIC CITY	**17**
What Is Art Deco?	19
Oil Capital of the World	24
Risk Takers	28
Waite Phillips	29
Visionaries	32
Bruce Alonzo Goff	34
PART II. TERRA COTTA CITY	**41**
Zigzag	45
Adah Robinson Residence: 1927–29	45
Oklahoma Natural Gas Company and Public Service Company of Oklahoma: 1928	46
Divine Deco (Boston Avenue Methodist Church and Christ the King): 1929	49
Eleventh Street Bridge: 1929	58
Halliburton-Abbott Building: 1929	61
Riverside Studio (Spotlight Theatre): 1929	62
Warehouse Market: 1929	66
Westhope: 1929	69

Contents

Gillette-Tyrrell Building (Pythian): 1930	70
Milady's Cleaners (La Maison, Inc.): 1930	73
Philcade: 1931	74
Tulsa Municipal Airport: 1932	77
Public Works Administration	78
Tulsa Union Depot: 1931	78
Tulsa Fire Alarm Building: 1934	81
Will Rogers High School: 1938	83
Streamline	86
John B. McGay Residence: 1936	88
Tulsa Monument Company: 1936	88
Holland Hall/Boulder on the Park: 1947	89
Newspaper Printing Corporation: 1947	89
PART III. LOST AND FOUND	**91**
From Bust to Boom	93
Herb Fritz: Deco Warrior	100
PART IV. ECHOES OF DECO	**103**
The Legacy Lives	105
William Franklin	111
Appendix. Tulsa Art Deco Chart	115
Notes	127
Bibliography	131
Index	137
About the Author	143
About the Photographer/Photography Manager	144

Foreword

LIVING ON TULSA TIME

In northeastern Oklahoma, on a bend in the Arkansas River, is a thriving oasis of commerce and culture named Tulsa. Founded in the early 1830s as a Creek Indian settlement that later became a busy cattle-shipping center, Tulsa underwent drastic change soon after the turn of the twentieth century when oil was discovered in the nearby Red Fork and Glenn Pool fields. The boom was on.

Oil made Tulsa. Promoters championed the town as the ideal headquarters for oil captains to conduct financial business and establish their offices and homes. The lure of black gold swelled the city's population as the influx of new Tulsans built schools, hotels, churches and even an opera house. By 1912, the city was becoming known as the "Oil Capital of the World." That sobriquet stuck for more than seventy years.

Tulsa became a city that believed its own publicity. On New Year's Eve 1916, an editorial on the front page of the *Tulsa Daily World* echoed a feeling of pride shared by many citizens:

> *The greatest year in the history of Tulsa's phenomenal growth from the village of a few short years ago, to the industrial metropolis of the state, and leading oil city in the world will be brought to close tonight when the hands of the clock swing over from the year 1916 to 1917. It will leave upon the pages of a municipality historic achievements which to Tulsa and her people have been but natural evolution and growth, but to other cities and people of other sections of the country have far surpassed their belief of city building.*

Opportunity was limitless. Anything was possible. The excitement of more oil discoveries in the region quickly gave birth to a movement of community pride and spirit. Shortly after World War I, as the 1920s began to roar, Tulsans fully committed themselves to civic and cultural development. They also faced considerable growing pains, a litany of problems to surmount and crises that threatened irreparable harm to the very fiber and fabric of the city's future. Some were acts of God, and some were acts of men. Yet even the horrific racial conflict of 1921, stirred by elements of the Ku Klux Klan, could not smother the aspirations of the majority of Tulsans, regardless of race or religion.

In the early 1920s, many residents, including the victims of bigotry and ignorance, tried to move forward. They were filled with a sense of purpose. The decade became a time for elegance and mischief. Tulsa quickly evolved into a haven tailor-made for risk takers and entrepreneurs who came in great numbers, following the scent of Oklahoma crude. Rough-and-tumble oil tycoons arrived with sixth-grade educations and nouveau riche ambitions. They swigged the best bootleg whiskey neat, literally and figuratively rolled the dice and cut the cards and blew clouds of cigar smoke in the face of Lady Luck.

In 1927, just eleven years after the newspaper declared 1916 "the greatest year" in the city's history, it all seemed to come together for Tulsa. The city had become hot stuff, with plenty of opportunity and lots of sass. The nation was between wars and on the wagon, and Tulsa was dead sure of its future. That year, Tulsa's identity had become so connected to petroleum that an oil-patch town in Wyoming took the name Tulsa in honor of the Oil Capital of the World. Not to be outdone, oil hunters deep in the heart of Texas followed suit and named their settlement Tulsa after the big Oklahoma boomtown.

By 1927, Tulsa was the headquarters of fifteen hundred oil-based companies. Black gold flowed like the lugs of ninety-proof booze that bootleggers dropped off at Masonic lodges, oil barons' homes and politicians' offices. It was a time for a host of rascals with a streak of larceny in their hearts smelling of bay rum and pomade and clad in Kansas City suits and glossy wing-tip shoes.

Working stiffs with enough moxie could make a buck. If you lived on the west side of the Arkansas in 1927 and could take a punch and then deliver a knockout, if you could roll up your sleeves and weren't allergic to hard work and if you didn't mind being bathed in sweat and raw crude oil, then you were definitely in the right place at the right time. It also helped if you had white skin.

Foreword

The wounds of the appalling massacre of untold numbers of black citizens just six years before were far from being healed. That process would take many years and still remains a work in progress. But the ashes and blood of the ravaged thirty-five-block Greenwood District were stirred into a mortar of resiliency that bound people together and kept hope alive.

The summer of 1927 was hot, but not nearly as hot as the music scene in Greenwood, where sweet jazz reigned. That summer, a twenty-three-year-old piano player from New Jersey was in town with a touring vaudeville act playing at the Dreamland Theatre on Greenwood Avenue. He was awakened in his bed at the Red Wing Hotel by the Blue Devils, a jazz band performing on the back of a flatbed truck. He had never heard anything like it. That night changed his life, and he later said it was the single most important point in his musical career. That young musician became known around the globe as Count Basie.

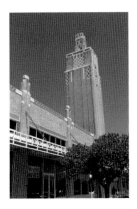

Warehouse Market tower.

Meanwhile, at McNulty Park—which in 1921 had served as a temporary holding pen for terrified black families displaced by white rioters burning their homes—baseball fans were screaming themselves hoarse. Their beloved Tulsa Oilers, led by "Boom-Boom" Beck, Stew Bolen, Red Kress, Rollie Naylor and Guy Sturdy, finished in first place in the Western League. But in '27, nobody in the bleachers knew that in just two years, the ballpark—where Babe Ruth played exhibition games and Jack Dempsey boxed—would be demolished to make way for the brick and terra-cotta Warehouse Market.

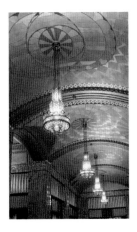

Philcade lobby.

Construction sites were popping up all over town. Waite Phillips, who had accumulated a fortune from oil, was responsible for many of the new buildings, such as the ornate Philtower, erected in 1927 and dubbed the "Queen of the Tulsa Skyline." A few years later, he built the magnificent Philcade just across the street. Yet by far the grandest personal achievement for Waite Phillips in 1927 was the completion of his palatial family home, Villa Philbrook, which Edna Ferber pronounced "wasn't a house at all, but a combination of the palace of Versailles and the Grand Central Station."

Foreword

Until the Phillips family moved into the sprawling villa, their home in 1927 was a brick residence on South Owasso Avenue in a prime neighborhood. Just two doors away was the residence of Cyrus Stevens Avery and his family. Avery, a businessman and civic leader, was largely responsible for the campaign that created Route 66, the brand-new highway linking Chicago to California that came right through Tulsa. In 1927, just a year after the new path across two-thirds of the continent became official, Avery established the U.S. Highway 66 Association, and he soon became known far and wide as the "Father of Route 66."

Both Cy Avery and Waite Phillips attended the banquet held on the evening of September 30, 1927, at the Mayo Hotel to honor Charles Lindbergh, who just a few months before had made his historic solo flight from New York to Paris. Earlier that day, "Lucky Lindy"—on an aeronautics promotional tour sponsored by Daniel Guggenheim—landed the *Spirit of St. Louis* at McIntyre Field. A throng of curious well-wishers greeted Lindbergh, a rather serious young man not prone to showing any emotion to acknowledge his multitude of admirers. In honor of "Lindbergh Day" in Tulsa, all the schools were closed. The roads from the airport were lined with cheering crowds all the way to the fairgrounds, where more than twenty thousand people—nearly one in seven Tulsans—waited to hear the "Lone Eagle" briefly speak without notes. Then the procession of dignitaries and their famous visitor headed to downtown Tulsa, where they paraded through a "canyon of skyscrapers" and an avalanche of ticker tape and confetti.

That evening during the dinner on the roof of the Mayo Hotel, the guest of honor politely chided the city leaders present for allowing a place as grand as Tulsa to not have a proper airport. Waite Phillips, Cy Avery, oilman Bill Skelly and other captains of industry heard Lindbergh loud and clear. They formed the Tulsa Airport Commission and, along with more than forty other prominent Tulsans, put up the money to purchase the land for a new airport. The following year, Tulsa Municipal Airport was open and soon became one of the busiest in the nation. By 1929, the airport led all others in the world in paid passenger volume. Then in 1932, the city tore down the crude one-story wood and tar-paper temporary terminal and unveiled an elegant Art Deco passenger terminal topped with a control tower and an impressive fifteen-hundred-foot asphalt runway.

Tulsa had every reason to be optimistic. The attitude of the city's movers and shakers and power brokers was reflected by the top popular tunes of 1927, such as "I'm Looking over a Four-Leaf Clover," "Blue Skies" and "The Best Things in Life Are Free."

Foreword

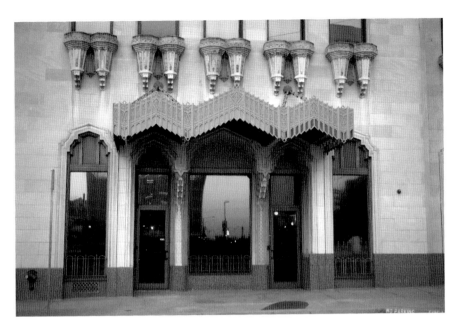

Oklahoma Natural Gas Building (ONG).

Nowhere was the city's optimism more apparent than in a building boom that was well underway in 1927. That year, construction costs in downtown Tulsa alone were averaging $1 million a month. Within three years, Tulsa had more buildings of ten stories or more than any other city of its size in the world. Tulsa's skyline was rapidly changing, fueled by prosperity and the critical need to erect corporate palaces.

The timing could not have been better. Tulsa's need to build coincided with the birth of a distinctive style of architecture and design that not only impacted the 1920s but also pervaded the Great Depression years and the New Deal before colliding head-on with World War II. It was a fresh, sassy and daring approach that later would be called Art Deco.

Art Deco's roots came from many sources. Influences ranged from the Latin and Mayan designs brought to light during the Mexican Revolution to Egyptian motifs that became popular in the 1920s after the opening of Tutankhamen's tomb in the Valley of the Kings on the west bank of the Nile. The discovery of the mummified body of King Tut, surrounded by jewelry, statues, weapons and clothing, helped people to focus on something new and exciting and not the somber news after World War I.

The craze for all things Egyptian was a perfect fit for the sheiks and shebas of the Jazz Age. It impacted fine art, music, fashion, film, furniture

Foreword

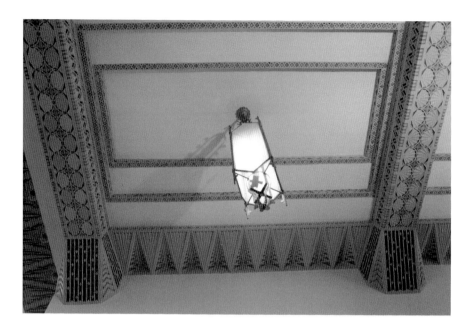

Above: Pythian Building lobby chandelier.

Left: Southwestern Bell Main Dial Building.

design and, most definitely, architecture. Egyptian designs inspired the monumental bas-relief figures, stylized lightning bolts, fan patterns, polychrome terra-cotta panels and geometric light fixtures found in many Art Deco structures.

The main launching point, however, was in Paris at the 1925 Exposition Internationale des Arts Décoratifs et Industriels Modernes (International Exhibition of Modern Decorative and Industrial Arts). Although the term *Art Deco* was not popularized until the late 1960s, when there was a significant revival in the style, Art Deco's name and very existence are derived from the 1925 exposition and the other influences. At the time, many called the movement the *style moderne* and compared it to the beginning of the Italian Renaissance. In the last half of the 1920s and beyond, this new and distinctive style swept the nation and blessed Tulsa with an abundance of new and stunning architectural wonders.

The city proved to be a perfect setting for the new architectural form. Tulsa attracted some of the nation's most talented architects, including Bruce Goff, Francis Barry Byrne, Frank Lloyd Wright, Joseph R. Koberling Jr., Leon B. Senter, Frederick Kershner and many others. Like the risk-taking oil barons who were their clients, these architects were not afraid to take chances. The Art Deco legacy they left behind endures.

Tulsa's Art Deco architectural treasures, both large and small, are not only a tribute to a fabulous era but are even more significant today because the many examples of residential, commercial and ecclesiastical Art Deco have helped in the revival of the downtown area and have rejuvenated the city. Risk takers—thought to be an endangered species—are making a comeback. The energy level is high, and watches are again set on Tulsa time.

—Michael Wallis
Best-selling author

ACKNOWLEDGMENTS

This book would not have been possible without the assistance of Sam Joyner. He scouted the city with me in search of Art Deco, and after taking hundreds of photographs, he evaluated and submitted images in the required format. All photographs are by Sam Joyner unless otherwise indicated. Sam's dedication and patience were invaluable.

I am indebted to Steve Gerkin for helping me to secure the contract to write this book, to Hazel Rowena Mills for editing and proofreading the work and to my editor Ben Gibson for his belief in the need for this book.

Early on in the book's development, I received sage advice from my brother James Fitzgerald, a longtime New York editor and literary agent. Thank you, Jim.

My sincere appreciation goes to George Day, a Tulsa architect and former student of the renowned Bruce Goff. George shared with me his insight and many personal memories of Goff.

My thanks also to the following individuals and organizations: Tom Costner, David Halpern, Ian Swart, Tulsa Art Deco Society, Tulsa City-County Library, Tulsa Foundation for Architecture, Tulsa Historical Society and Tulsa Preservation Commission.

Last but certainly not least, I must offer my gratitude to my pair of feline muses, Juniper and Martini, who were with me every step of the way.

• PART I •
MAGIC CITY

Tulsa is the "Magic City."
Young, prosperous
New oil spewing from the ground.
A dream land,
The most modern city in the West.
—Dunn's Western Travel Guide, *1920*

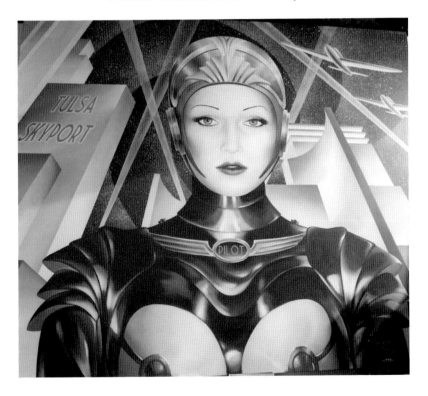

"Tulsa Skyport." *Courtesy William Franklin.*

WHAT IS ART DECO?

Exotic, colorful, luxurious, exuberant, glamorous, sleek, smooth, polished, fashionable, crass, prestigious, popular, unpopular, elegant, splendid, expensive, cheap, vertical, horizontal, old-fashioned, modern.

Considered a treasure by some, a calamity by others, Art Deco has always been wrapped in controversy. In fact, the term itself defies definition. The style touched all aspects of everyday life in America from 1925 to 1940. Hand in hand with the times, at once jazzy and cheerful during the Roaring Twenties, Art Deco turned sleek during the following decade and went streamlining into the 1940s, with an overlay of 1930s old-world classicism, thanks to the efforts of President Franklin Delano Roosevelt.

It was not by chance that Bruce Goff, twentieth-century American architect, loved music as much as he loved art and architecture. He was not alone in his love of the arts and his desire to reject the popular view of his craft and embrace a daring new approach. Perhaps unknown to the young Oklahoman, the same thing was happening in Paris, France, where the Ballets Russes was founded in 1909, followed less than two decades later by the 1925 Exposition Internationale des Arts Décoratifs et Industriels Modernes (International Exhibition of Modern Decorative and Industrial Arts).

Sergei Diaghilev, a disenchanted Russian nobleman who had moved to Paris, founded the Ballets Russes. He challenged the classic standard of perfection by gathering together dancers, musicians, painters and sculptors

to produce innovative music and visual art. Performances reinvigorated modern dance by featuring artistic collaboration among choreographers and dancers (Nijinski, Balanchine), composers (Stravinsky, Debussy), set designers (Picasso, Matisse) and costume designers (Chanel, Dali), to name only a few. The company performed in Paris and caused a sensation in London and ultimately around the world but never in Russia, despite its name. Male dancers were featured as prominently as their female counterparts. Light pastel backdrops were abandoned in favor of brightly colored stage designs. Music varied from the bombastic to the genteel.

The term *Art Deco* can be traced to the 1925 International Exhibition of Modern Decorative and Industrial Arts, held in Paris. The event, featuring artistic products with a modern style, was the idea of decorative artists who had been generally ignored in earlier salons, where their work had been considered inferior to that produced for centuries by painters, sculptors, graphic artists and architects. Decorative craftsmen were now no longer satisfied with being recognized as second-class citizens when it came to fine art. They felt deserving of the title "artist" and sought recognition for producing decorative art that was practical, not simply beautiful. Art Deco was artistic beauty created to be experienced and savored, not just appreciated from a distance.

Consider the following 1920s vintage advertisement from the *Rammer Jammer*, the University of Alabama humor and literary student publication:

Langrock Fine Clothes
Dressing well and correctly is now entirely a matter of pride.
Langrock Fine Clothes
Tailored by hand of British Woolens, are produced for men that know and appreciate quality plus value[1]

Visitors to the Paris exhibition had been dazzled by the possibilities of living in a cheerful world of design and fashion. Almost a decade later, at the 1933–34 Century of Progress International Exposition, a World's Fair in Chicago, efficiency was the first order of the day for visitors faced with the threat of financial ruin and another war. The vivid color and glamour of Art Deco in the 1920s gave way in the 1930s to a more practical elegance and the desire to escape. This period was a celebration of America's Machine Age. Cars were no longer bulky like the Ford Model A. They were sleeker, faster and streamlined, as described in an advertisement from the archives of *Hemmings Daily*, a classic car news source:

Graham: The Luxury Car in the Low-Priced Field!
…It Costs Little More than the Lowest
Here is America's new "Style Setter"! A car so smart, so distinctive that millionaires will purchase it. But the family of average means can afford it. The price is unbelievably low for a car so big, so handsome, so high-powered.

It makes your blood tingle just to drive it. Graham is alive with power. A car so spirited you'll never know its peak of performance. You'll never even want to! In a Graham, you're the "king" on any road.[2]

Although Art Deco made its debut in 1925, decades passed before the term was commonly used. English historian Bevis Hillier is credited with coining it in the late 1960s when he researched and wrote *Art Deco of the 20s and 30s*, published by Studio Vista in 1968. Three years later, as a result of his book reviving interest in the style, Hillier curated a major Art Deco exhibit at the Minneapolis Institute of Arts.

The truth of the matter is that it really is difficult to define Art Deco. To a great extent, the various styles that emerged during the 1920s and into the 1940s overlapped. While the exotic decorative art of the 1920s morphed into the streamlined look of the 1930s, another style, referred to as PWA, appeared at the same time. It reverted in look to a more classic style of architecture with heavy, substantial structures built to accommodate the new high-performance, practical forms of transportation. As Tony Fusco writes in the introduction of his book *The Official Identification and Price Guide to Art Deco*, "Like it or not, Art Deco is the title that seems destined to refer to the stylish production of the entire era, from the end of Art Nouveau early in the century to just prior to World War II."

For purposes of this book, *Art Deco* refers to three distinct but related movements of modern architecture that evolved in the early twentieth century: Zigzag, PWA and Streamline.

ZIGZAG: The sky was the limit for buildings created to look taller than they really were, with vertical features running in strips, topped by a tower. Colorful and ornamental, the skyscrapers were clad in the fashion of the Roaring Twenties, when they first appeared. Terra cotta (baked earth), a hard, fired clay, was used to create a plethora of shapes, including figures found on buildings in Tulsa, Oklahoma, such as the Boston Avenue Methodist Church circuit riders, geometric forms in the Warehouse Market medallions and elaborate designs so beautifully incorporated into the Pythian façade pinnacles.

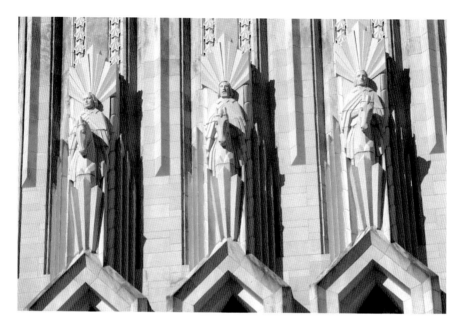

Boston Avenue Methodist Church, circuit rider figures.

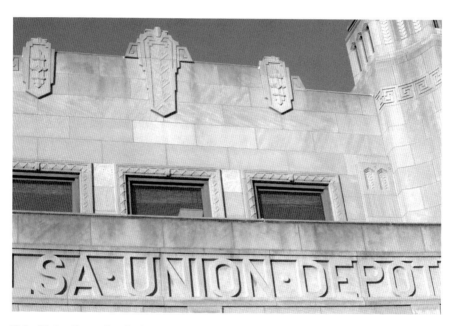

Tulsa Union Depot façade detail.

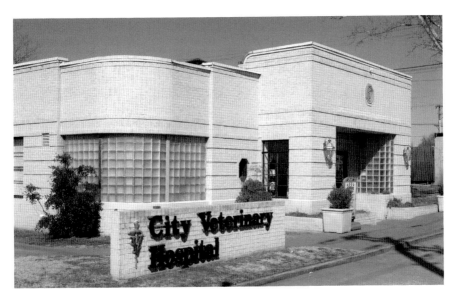

City Veterinary Clinic.

PWA: Thanks to President Franklin Delano Roosevelt's New Deal, the Public Works Administration (PWA) provided employment for upkeep and creation of new infrastructure throughout the country. The Works Progress Administration (WPA) created special projects to employ those who needed jobs and were not working in construction. The Art Deco style labeled as PWA resulted in heavy, bulky buildings exemplified by the Tulsa Union Depot, which conveyed strength and permanence to victims of lost wealth and income.

STREAMLINE: After dancing into the 1930s, Americans, ready to escape their misfortune, jumped into cars, boarded planes and set sail into the 1940s. Life was streamlined with new products packaged to swiftly get to consumers armed with credit cards, the new alternative to cash. The glow of neon lured customers, as well as lighted streets catering to new, powerful automobile models. Pigmented glass such as Vitrolite and porcelain panels replaced terra cotta, and the sharp angles of Zigzag gave way to rounded glass-bricked windows such as those in Tulsa's City Veterinary Clinic.

Perhaps the real beauty of Art Deco is the fact that it is so difficult to define. Apparently, any effort to do so does result in a better understanding. In the words of a *Hemmings* subscriber reacting to an article about 1930s automotive styling, "Huh, and here I thought that era's design was named after some guy named Arthur Deco who specialized in streamline design."[3]

OIL CAPITAL OF THE WORLD

Tulsa sparked to life in the mid-1830s beneath the boughs of a great post oak on a hill overlooking the Arkansas River. Here a band of Creeks settled and lit a new council fire after having been driven out of their Alabama homeland by President Andrew Jackson. As noted historian Angie Debo would write many years later, "It was a strange beginning for a modern city. The flickering fire, the silent valley, the dark intent faces, and the wild cadence of ritual."[4]

The settlement, a precocious child cared for by Creek ranchers, gained prominence in 1882 when the railroad reached the community and cattle could be shipped to other markets. The population grew, made up primarily of cowboys, railroad workers, merchants and roaming outlaws, turning Tulsa into a wild cow town.

Oil was first discovered in the Tulsa area on June 24, 1901, at Red Fork, just across the Arkansas River from Tulsa, and less than four years later in the giant Glenn Pool south of Tulsa. The word was out, and it spread like wildfire across the country. Oil derricks were so numerous west of the river that it was almost impossible to keep count of them. Images of gushers flashed across the country, offering a glimpse of where most of the nation's oil was coming from.

Tulsa was where industry news was being made. Fueled by the spirit of risk takers, a Creek settlement turned cow town turned rail center was christened "Oil Capital of the World."

It was the Midas touch of the oil barons in the early 1900s that ushered the city into adulthood, spawning corporate palaces and elegant estates.

Taking the lead in converting downtown Tulsa to a metropolitan center was Josh Cosden, founder of what later became Sun Oil. He built the first downtown skyscraper in 1918 on the site of the city's first schoolhouse, which had been established as a mission in 1885 on Creek Indian land. The sixteen-story Cosden Building at Fourth Street and Boston Avenue was reported to be the world's tallest concrete structure. A penthouse complete with art masterpieces and an expensive pipe organ topped the building but was destroyed by fire before the "Prince of Petroleum" ever took up residence.

By 1923, two furniture dealers, Cass and John Mayo, began to construct their eighteen-story hotel that would open in the spring of 1925. Not to be outdone by an oil baron, the Mayos also topped their building with a penthouse complete with outside balconies, ideal for relaxing and enjoying the ever-changing urban scene.

In January 1927, construction began on the Philtower building. With interests beyond the Okmulgee County oil field where his success had been unparalleled, businessman Waite Phillips made a fortune in the oil patch and then dealt in real estate and banking ventures. After traveling abroad in search of architectural ideas for an office and residence in Tulsa, Phillips engaged Kansas City architect Edward Buehler Delk to design a neo-Gothic office tower with Art Deco flourishes at the corner of Fifth Street and Boston Avenue, one block south of the Cosden Building.

Waite Phillips's newest commercial building venture, the Philcade, a nine-story retail-office complex and Art Deco palace, was completed across Fifth Street from the Philtower in 1930, a year after construction had begun.

Game on! Competition was now official. No sooner had the Philtower risen in downtown Tulsa in 1928 than J.J. McGraw, president of the Exchange National Bank, decided to add a tower to his twelve-story bank building, igniting yet another rivalry.

Enter Dr. Sam Kennedy, an early Tulsa physician who, after retiring, joined the ranks of wealthy oilmen. He had sold the property where his home was located at Fourth and Boston to a developer in 1915. Four years later, Kennedy repurchased the property, planning to build an addition to the existing office building that would tower over the Exchange National Bank across the street. Kennedy's plan fell victim to the stock market crash in 1929. In the end, the twelve-story Exchange Building rose fifty-seven feet higher than the Philtower. It reigned as Tulsa's tallest building until 1967, when another bank, Fourth National, was completed.

Art by William Franklin.

With an eye to offering businessmen a chance to forget the pressures of their day, the new Boston Avenue Methodist Church structure was in progress at the south end of Boston Avenue on Thirteenth Street.

Once those who struck oil on the west side of the Arkansas decided to locate their offices in downtown Tulsa on the east side of the river, the city became a bustling haven of construction, all of which stretched up into the sky.

Ada, Oklahoma, businessman W.M. Immanuel remarked in a 1929 interview in the *Tulsa Tribune*:

> *It was but a few months ago that I was in Tulsa, and I thought I would have no trouble in recognizing the town. However, when I alighted at the Frisco station I saw a strange skyline, so I just didn't know whether I was in Tulsa or not.*

The last time I was here the Philtower was nearing completion. But when I looked up that Boston avenue canyon from the station I saw two other towers rearing their spires into the sky—the Exchange National Bank building and the Boston Avenue Methodist Church tower. Neither was there when I looked up the canyon earlier in the year, so I think I had a right to doubt if I was in Tulsa.

You erect new buildings and change your skyline here so often that I am going to have to take to coming here oftener than I have, else I am going to find myself getting lost in Tulsa.[5]

RISK TAKERS

The lure of black gold captivated the interest of men such as J. Paul Getty, W.G. Skelly, Robert McFarlin, Harry Sinclair and Josh Cosden. Willing to gamble, they came to Oklahoma, took risks and drilled for oil. These were spirited men. They were optimistic and daring. They were *wildcatters*, a term coined in Pennsylvania to describe speculators who had taken their chances drilling in remote areas populated with wild animals. Tales were told about some of the daredevils adorning their oil rigs with wildcats they had shot and stuffed.

Evidence of the early oil barons can still be seen throughout Tulsa. They tapped into their wealth to construct stunning office buildings and homes during the city's boom years.

Josh Cosden managed to earn and lose two great fortunes. Cosden came to Tulsa in 1911 and by 1913 was operating one of the world's largest independent refineries. His personal wealth grew to $50 million. He built Tulsa's first skyscraper, the Cosden Building—today's magnificent Mid-Continent Building—before moving to New York, where he lived in splendor.

By 1925, Cosden was broke. He made a comeback in Texas in 1928 and amassed $15 million but lost it all during the Great Depression of the 1930s. When the "Prince of Petroleum" died in 1940 aboard a train traveling from Arizona to El Paso, he was again broke.

J. Paul Getty amassed a fortune that would make him the wealthiest man in the world, but little remains today of his presence in the city.

In contrast to other risk takers, Waite Phillips had business acumen that enabled him to avoid the pitfalls that snared Cosden, who ran out of luck. Unlike Getty, Phillips continues to be recognized today for his philanthropy that fueled the city's cultural legacy.

WAITE PHILLIPS

Waite Phillips initially followed in the footsteps of his older brothers—Frank and L.E., founders of Phillips Petroleum—but it was not long before he left their banking and oil ventures to step out on his own.

From the time he was a boy in Iowa, Waite had always been on the move. Born on January 19, 1883, in Conway, Iowa, Waite and his twin brother, Wiate, left home sixteen years later to travel west in pursuit of adventure. Waite later made note of their journey in his diary: "These twin boys were not outstanding ones except as to their unusual energy and their intense interest in nature and exploring what lay beyond the hills of their farm home, especially the country they visualized in the West with its mountains, streams, and desert lands."[6]

The boys' grand escapade came to a sorrowful end in Spokane, Washington, where nineteen-year-old Wiate died from peritonitis after emergency surgery for acute appendicitis. Waite was devastated. The loss of his twin brother would haunt him throughout his life. Until the end of Waite's life in January 1964, eight days after he turned eighty-one, he would mark their birthday by going off alone, laying out the contents of an old tobacco tin and recalling earlier times. The assortment of rolling papers, trinkets, pictures of girls and a photograph of Wiate and Waite were the things he had removed from his twin's pockets when he died soon after the turn of the century.

Waite Phillips returned from his early travels in the West experienced in railroad construction, lumber milling and fur trapping, all jobs that had sustained him and his brother. After earning a diploma in business from Western Normal College in Shenandoah, Iowa, he went to work in the coal-mining industry for two years.

In 1906, Phillips traveled to Indian Territory and worked in the oil fields for his older brothers Frank and L.E., headquartered in Bartlesville, Oklahoma. Three years later, he married his longtime Iowa sweetheart, Genevieve Elliot. The couple began to raise a family and remained in Bartlesville until

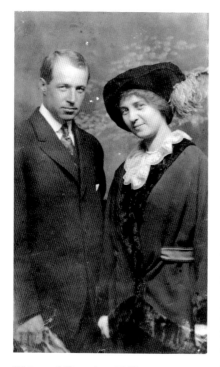

Waite and Genevieve Phillips. *Courtesy Tulsa Historical Society.*

1914, when they moved to Fayetteville, Arkansas, where Phillips opened an oil-marketing firm.

He was restless, a quality that would carry him through successful ventures during his whole life. A man of good fortune, he was masterful when it came to timing. In 1915, he moved his family back to Oklahoma, settling in Okmulgee, where they would remain until the fall of 1918, when they moved to Tulsa.

Not satisfied limiting himself to the business of oil, Phillips expanded his interests and was elected chairman of the board of the city's First National Bank and Trust Company. Turning to real estate development in the thriving city, he built the Beacon Building, topped with a beacon-light tower that was removed in 1976. Phillips added two magnificent office buildings—the Philtower and Philcade—to the evolving downtown skyline. Two miles away, on what had been Creek Indian land, he bought more than seventy acres, fifty of which he then sold for residential development, keeping the remaining acreage for his new family residence. He commissioned Kansas City architect Edward Buehler Delk to design the palatial estate and Hare & Hare to create gardens, including a knoll for a small outdoor temple.

The Phillips family moved into Villa Philbrook during the spring of 1927. Five hundred guests—a veritable *Who's Who*—were invited to enjoy a gourmet meal and lift glasses of champagne in a toast to the grand opening of the villa, filled with flowers for the evening. One of the tuxedo-clad waiters described the moment years later as the most dramatic he ever saw in Tulsa society: "At about 8:30 a hush fell over the crowd. I looked up on the first stairway landing and there was Mrs. Genevieve Phillips," recalled Tulsan Julius Williams many years later. "She had been descending the stairs and stopped for a moment to look at the party going on below. She had a faint smile and carried some flowers. She wore a gown of fine

material. Those in the party applauded as she came down the stairs to join them. Then they cheered."[7]

Since traveling west with his twin, Waite Phillips had always felt an affinity for that part of the country. In 1922, he purchased a three-hundred-thousand-acre ranch near Cimarron, New Mexico. He initiated farming and livestock operations, built a summer home for the family and created mountain trails leading to hunting and fishing lodges. Villa Philmonte was his retreat from the pressure of business.

It was not the acquisition of wealth that appealed to Waite Phillips; it was the pursuit of success. When he did acquire his fortune, he was more concerned with putting it to good use than saving it.

In 1938, he donated the twenty-three-story Philtower and his ranch in New Mexico to the Boy Scouts of America. The city of Tulsa benefited from much of his philanthropy. In addition to supporting cultural groups, educational and scientific endeavors at the University of Tulsa and St. John Hospital, he and Genevieve gave Villa Philbrook to the city to be used as a museum for Native American art and artifacts. "Waite placed special emphasis on the importance of Indian collections to perpetuate the culture of a people to whom Oklahomans are especially indebted."[8]

In 1945, Waite and Genevieve Phillips moved to California, where, like Theodore Roosevelt, Phillips felt he was west of the West. He remained active in business until his death on January 27, 1964. He bequeathed $7.5 million to charities, hospitals, colleges and the Boy Scouts.

Unquestionably, one of Waite's most cherished epigraphs best summed up the legacy he left behind: "The only things we keep permanently are those we give away."[9]

VISIONARIES

Many outstanding architects were responsible for Tulsa's recognition as an important Art Deco metropolis. All of them were daring and willing to try something new in design. All of them were true risk takers, just like the oil barons who financed their work. When it came to innovative and original design, however, the most prominent visionary and risk taker of all was Bruce Goff.

Following is a partial list of Tulsa Art Deco designers:

Arthur M. Atkinson (1891–1949)
 Medical and Dental Arts Building (1927)
 Oklahoma Natural Gas (1928)
 Daniel Webster High School (1938)
Francis Barry Byrne (1883–1967)
 Christ the King (1928)
John Duncan Forsyth (1886–1962)
 John Duncan Forsyth Residence (1937)
 Daniel Webster High School (1938)
Bruce Goff (1904–1982)
 Day Building (1926)
 Adah Robinson Residence (1927)
 Tulsa Club (1927)
 Page Warehouse (1927)
 Guaranty Laundry/Page Van Lines (1928)

 Skelly Building Addition (1928)
 Boston Avenue Methodist Church (1929)
 Riverside Studio/Spotlight Theatre (1929)
 Midwest Equitable Meter Company (1929)
 Merchant's Exhibit Building (1930)
Frederick V. Kershner (1904–1980)
 Tulsa Fire Alarm Building (1931)
 Tulsa Municipal Airport (1932)
 Union Bus Depot (1934–35)
 Burtner Fleeger Residence (1937)
 Century Geophysical Corporation (1946)
Joseph Koberling (1900–1990)
 Medical and Dental Arts Building (1927)
 Public Service Company of Oklahoma (1929)
 Adah Robinson Residence kitchen addition (1929)
 Genet Building/American Airlines Building (1930)
 Whenthoff Residence (1933)
 G.C. Pride Residence remodel (1935)
 State Theater (1935)
 John B. McGay Residence (1936)
 Will Rogers High School (1938)
 City Veterinary Clinic (1942)
 Fire Station #7 (1947)
 Fire Station #14 (1950)
 Home Federal Savings/BOK (1956)
 KVOO Radio Station/KJRH Television Studio (1956)
Harry Hamilton Mahler (1876–1975)
 Tulsa Monument Company (1936)
 Security Federal/Court of Three Sisters (remodeled 1937)
B. Gaylord Noftsger (1897–1979)
 Warehouse Market (1930)
Edward Saunders (1878–1964)
 Gillette-Tyrrell/Pythian (1930)
Leon B. Senter (1889–1965)
 Fawcett Building/Stanolind/Amoco (1926)
 Philcade (1931)
 Tulsa Municipal Airport (1932)
 Union Bus Depot (1935)
 Will Rogers High School (1938)

Rialto Theatre (1948)
Service Pipeline Building/ARCO Building (1949)
Mayo Motor Inn (1950)
William H. Wolaver (1900–unknown)
T.N. Law Residence (1935)
Daniel Webster High School (1938)
Day and Nite Cleaners (1946)
Frank Lloyd Wright (1867–1959)
Westhope (1929)

Bruce Alonzo Goff

"What do you want?" scowled the fellow with bulldog jowls.

"I want you to take this kid and make an architect out of him!" demanded Corliss Arthur Goff, who, in 1915, with a fearlessness fueled by alcohol, had dragged his eleven-year-old son into Rush, Endacott and Rush, an architecture firm in downtown Tulsa.

"Do you want to be an architect, Son?" growled Rush.

"I don't even know what an architect is," the boy replied.

"Well, you can be an architect if you want to," said Rush, "but you have to want to. I can't pay you anything until you are able to earn it, but you can be our office boy and I will teach you the fundamentals of architecture."[10]

So began the professional life of Oklahoma's most daring and imaginative architect.

It was perhaps fate that Frank Lloyd Wright celebrated his thirty-seventh birthday on June 7, 1904, the same day Bruce Goff was born in Alton, Kansas. Wright would inspire much of Goff's work, and both men would have a profound influence on twentieth-century American architecture.

Goff's father was a jeweler. His mother, Maude, was a schoolteacher. The family moved to Colorado and eventually to far western Oklahoma, an area Goff described as the hinterlands: "a place where everything was dusty and all the people were plain vanilla."[11] The young boy passed the time drawing buildings, palaces and cathedrals on the back of scraps of wallpaper.

Unimpressed with most of the townspeople, Goff was drawn to the last of the Native Americans living in the area and was fascinated by how they coped with their drab existence. Their ancestors had been forced into Indian Territory by politicians eager to help settlers move west, but these

victims of Manifest Destiny had not surrendered to the bleak new landscape. They wove blankets with colorful designs that set them apart from everyone else and created a culture in a place where there was not supposed to be any culture. They sang the songs of their fathers and celebrated ancient ceremonies clad in leather garments adorned with feathers and beads that captured light and made music as they danced.

It was there in the hinterlands that Bruce Goff developed a passion for color and ornamentation, both of which would become his signatures. It was there that he identified with the native people and learned to defy expectations.

In 1915, the Goff family moved again, this time to Tulsa. All of Bruce's drawings inspired Corliss Goff to take his eleven-year-old son downtown to meet "old man Rush."[12] That was when the youngster stepped into the world of work as an office boy. His father had made a move that eventually would help jettison the city into Art Deco prominence.

Young Goff was made an apprentice and soon began work as a designer before the advent of Art Deco. An example of his innovative early work is the Prairie-style McGregor House at 1401 South Quaker Avenue in Tulsa. By 1929, at the age of twenty-five, Goff was made a partner in Rush, Endacott and Rush. His architectural accomplishments included Boston Avenue Methodist Church, one of the finest examples of Art Deco architecture in the United States, and Riverside Studio, a home so unusual that Tulsans referred to it as "Curiosity Corner."

But Bruce Goff had only just begun. He was curious and drew inspiration not only from architecture greats Louis Sullivan, Frank Lloyd Wright and Antoni Gaudi but also from artists including Gustav Klimt, Maxfield Parrish and Erté. Goff loved Balinese music, and he was influenced by the composer Claude Debussy who, like Goff, was a prodigy and entered the Paris Conservatory at the age of eleven. Goff relished the landscapes, flora and fauna of Japanese woodblock prints, and he would incorporate them into his designs, especially in Shin'enKan, the home of Joe Price in Bartlesville, Oklahoma. If he had been given the opportunity to live an eternal lifetime, Bruce Goff would have specialized in all the arts. Instead, he incorporated all the arts into his idiosyncratic architectural masterpieces.

After being told that Boston Avenue Methodist Church was similar to the work of Frank Lloyd Wright, Goff wrote to Wright and received back from him a portfolio of drawings. They developed a friendship that lasted until Wright died in 1959. Late in his life, the egocentric Wright, not known to be generous with his praise for fellow architects, reportedly said, "Of all

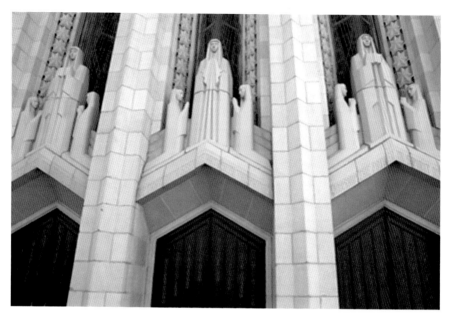

Boston Avenue Methodist Church.

the American architects, Goff is the finest designer." When the two first met, Wright advised that Goff not attend a school of architecture, where he would risk losing what made him Bruce Goff.[13] Ironically, it was this advice that led Goff to turn down an invitation from Wright to work with him at Taliesin, his Wisconsin residence and studio.

During the summer of 1927, Goff met Alfonso Iannelli, an artist, sculptor and architect who, after emigrating from Italy, had apprenticed in New York to Gutzon Borglum, the sculptor who later created the Mount Rushmore monument. Iannelli and Goff shared an interest in the highly personal nature of Native American culture. Like the European modernists in vogue at the time, both architects used geometric figures and color in their work. Barry Byrne, a Chicago architect who had been hired to design Tulsa's Christ the King Church, called on Iannelli to create the side-altar statues and the stained glass, some of the best in the United States. Byrne turned to Bruce Goff to design the ceramic mosaics for the side altars as well as the bishop's throne and the priest's bench. In spite of their combined efforts on Byrne's Christ the King Church, Iannelli declared that Goff's Boston Avenue Methodist Church was "a building that is the voice of the Twentieth Century, giving joy to beholders."[14]

In 1934, after Rush, Endacott and Rush was dissolved, Goff moved to Chicago and joined Ianelli's firm, but he was not comfortable working in the confines of an office. Goff began to freelance and took a part-time teaching position at the Chicago Academy of Fine Arts.

In Chicago, Goff had the opportunity to work with Vitrolite, an ornamental pigmented glass popular during the Art Deco period of the 1920s and 1930s. Versatile, lightweight and vibrant in its polished appearance, Vitrolite was an ideal material for the young architect, who enriched his projects with color and shine.

Goff enlisted in the U.S. Navy during World War II and designed military structures using surplus materials, including stainless-steel airplane struts. He returned to California after his discharge, and in 1942, he accepted an offer from the University of Oklahoma to teach in the School of Architecture. The next year, lacking a formal degree but recognized as a leader in his field, Goff was named chairman of the department.

Quiet and eccentric, Goff was devoted to his students. He believed in developing their innate talents rather than teaching them about design and construction. He inspired them to be artists—open-minded, spontaneous and personal—and to concentrate on the needs and personality of each of their clients.

It was important, Goff told his students, to focus on the landscape and the natural lighting in which their structures would be located. He hated right angles and straight lines. Instead, he incorporated triangles, circles, trapezoids and spirals into the open space that was at the heart of his work. He believed that architecture was not something to be looked *at* but looked *into*. University of Oklahoma architecture professor emeritus Flo Henderson recalled that Goff "was an extraordinary human being. He was like a sponge, soaking up ideas from different disciplines and applying them to architecture."[15]

In 1955, Goff relocated to Bartlesville—the headquarters town of Phillips Petroleum Company—and set up a studio in Frank Lloyd Wright's only skyscraper, the Price Tower. In addition to extensive travel and lecturing, Goff designed Shin'enKan, initially built as a bachelor studio for Joe Price and expanded over the span of twenty-five years into a family home and conference center, ultimately destroyed by fire in 1996. An avid collector of Japanese Edo art, Price was the son of H.C. Price, whose company built transcontinental pipelines across Canada and Alaska. Goff's last project was the Los Angeles County Museum of Art's Pavilion for Japanese Art, built to house Joe Price's Shin'enKan collection of Japanese paintings.

Before his death in Tyler, Texas, in 1982, Bruce Goff had broken the conventional mold of architectural thinking. He was bold and not afraid to take chances. His buildings were objects of intriguing beauty. Instead of a window, there might be a clear glass ashtray inlaid in a stone wall, breaking the sunlight into rainbows, or a turquoise scrap of waste glass twinkling with natural light. The flutter that whispers as you walk through a room might be from the ripple of white goose feathers covering the ceiling. Cellophane strips sparkle instead of chandeliers. A winding wooden trail might lead to beds suspended above like nests. Guests can sit in a conversation pit, and children can climb the tilted walls lined with soft white carpeting.

Unlike many in his profession, Goff was neither arrogant nor an egotist. Still, in his later years, he did not hesitate to show his contempt for much of the contemporary architecture appearing in Tulsa. "It seems to lack substance," he told a *Tulsa World* reporter in 1973. "You look at it and I like architecture you look into."[16]

Six years later, in an interview for the *Tulsa Tribune*, Goff mourned the passing of the spirited movement that had created the incredible inventory

Mayo Hotel, condominium interior.

McGregor Residence.

of Art Deco buildings in Tulsa. He longed for the flamboyance that "was in the wind" in Tulsa in the 1920s and 1930s.

"The country now is full of doubting Thomases and people who are copping out," Goff said. "There are too many people now who are thinking about what can't be done rather than how it can be accomplished."[17]

Bruce Goff also liked to say that he had been "scaring the hell" out of people with his one-of-a-kind designs. "We had a feeling that we knew we were on the outskirts of civilization," said Goff. "New York and others in the East always looked at this part of the country as a jumping-off place. But there was a generally progressive attitude and a lot of town spirit. We felt like we were wanting to build something and make something out of it."[18]

In 1955, Goff designed a one-of-a-kind home for John and Grace Lee Frank, founders of Frankoma Pottery Company in Sapulpa, Oklahoma. John Frank had studied architecture in Chicago in 1927 and conferred with Goff to design the modern semicircular home built with "Frankoma Green" glazed bricks. Twenty-seven years later, in a nod to the state where Goff had worked as a noted architect and professor, Goff's ashes were buried in a piece of Frankoma pottery in Chicago.

For the controversial genius who was Bruce Alonzo Goff, each project was a new beginning, a brand-new creation. He was wild and mischievous

and free, like a child of the 1960s. He reined in that spirit to meet the needs of the people he served. He created for his clients and students a world of endless possibilities. One thing is certain: Bruce Goff's architecture was never ordinary.

• PART II •
TERRA COTTA CITY

Queen City, Magic City, Magic Empire, Oil Capital, City Beautiful—Tulsa was to name and rename herself over the decades as her aspirations and her sense of identity evolved.[19]

Black gold sparked Tulsa to life in the early 1900s, but it was the touch of Art Deco that made the city sparkle.

Affluent Tulsans yearned for sophistication after stepping into the twentieth century and discovering oil. They kept up with the latest in fashion and acquired the most up-to-date furnishings, vehicles and everyday objects. Tulsa was no cow town anymore. Nor was it just another railroad stop along the line between the hustle of California and the bustle of New York. The city had come of age. It was a respected financial center. Its citizens had class, and they wanted the world to acknowledge their status.

The captains of the oil industry built corporate palaces such as the Philcade in Tulsa and palatial mansions, many of which were created in the distinctive style of architecture known as Art Deco. In keeping with the elegance, mischief, magic and drama of the times, the design reflected the merriment of the 1920s.

Downtown Tulsa was kept afloat during the Great Depression by oilmen, members of the chamber of commerce with investments in oil, not the stock market. But that did not prevent Tulsans from enduring reduction of salaries and loss of jobs. In spite of the challenges of the decade, construction continued, with Art Deco prevalent in the design of public buildings, including the Union Depot and the Fire Alarm Building.

During the late 1930s and early 1940s, Streamline Art Deco became most obvious in numerous upper-middle-class homes. It was also the design of choice for Silver Castle drive-in restaurants

and three movie theaters, all encouraging the public to move forward, away from the dusty 1930s.

The Oil Capital of the World took pride in earning the title Terra Cotta City.

Philcade detail, by William Franklin.

Warehouse Market façade detail.

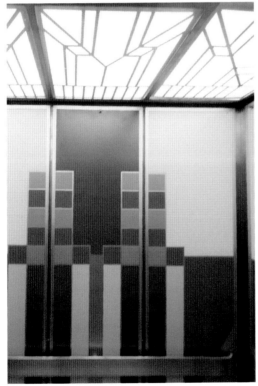

Above: Adams Building lobby detail.

Left: Pythian Building elevator interior.

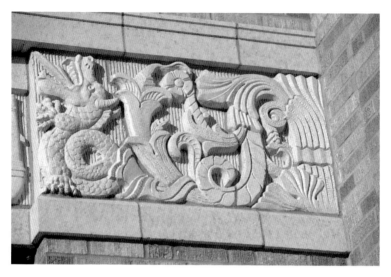

Tulsa Fire Alarm Building frieze detail.

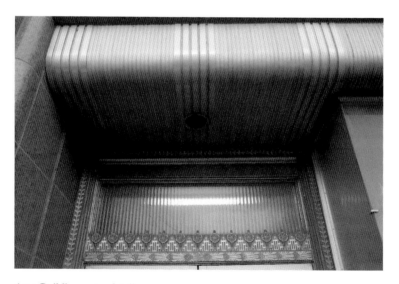

Arco Building entry detail.

ZIGZAG

Adah Robinson Residence

Adah Robinson Residence.

One of Tulsa's most well-known art teachers, Adah Robinson, played a major role in the design of the iconic Boston Avenue Methodist Church. She was also responsible for influencing two of the city's outstanding Art Deco architects, Bruce Goff and Joseph Koberling.

Goff designed Robinson's stucco house with leaded-glass windows. The fact that he and Robinson were collaborating on the downtown church might account for why he forgot to include a full kitchen in the home. Robinson, known to her friends as "Miss Bobbie," called on Koberling to provide a kitchen, insisting that it be inserted into a corner of the house so that the original plan not be changed.

Fortunately, through the years, the house at 1119 South Owasso Avenue has been carefully preserved by owners who have shown the same concern for it that Robinson did.

Oklahoma Natural Gas Company and Public Service Company of Oklahoma

During the 1920s, Tulsa enjoyed significant growth, with construction costs downtown averaging more than $1 million a month. By the end of the decade, there were more buildings of ten or more stories in downtown Tulsa than in any other city of its size.

Two utility buildings were early additions to downtown Tulsa's Art Deco scene. The founders of Oklahoma Natural Gas (ONG) and Public Service Company of Oklahoma (PSO), an electric utility, abandoned their otherwise conservative views and adopted the flamboyant architectural style that was appearing more and more frequently throughout the fast-growing urban area.

Arthur Atkinson's architectural firm was hired to design the two buff-colored utility buildings. ONG is a ten-story tapestry in brick soaring above a basement. PSO, five floors shorter and coated with Bedford stone, sits on a foundation that had been built in 1929 to accommodate additional floors if necessary, and in fact, two stories were added in 1961.

Joseph Koberling designed the exterior of ONG before traveling abroad for a year. Frederick Kershner, his friend and fellow architect at Atkinson's firm, completed it. The building opened in 1928, the same year that Tulsans flocked downtown to the Majestic Theater to see their first talking movie and across the river to delight in rides and dancing at the newly opened Crystal City amusement park.

Sadly, the two recreational centers fell victim to fire in later years and were ultimately demolished, but ONG was spared the same fate. In 1988, the property was vacated by the utility company and sold. With the exception of several tenants, it sat vacant until 2014, when Justin Thompson opened 624 Kitchen & Catering. One of Tulsa's premier chefs, Thompson hosts private events, and 624 is open for Sunday brunch. It is a savory combination—culinary delights served in the handsome refurbished ONG lobby—all with a taste of Art Deco.

When the PSO building was completed in 1929, it was a standout because company officers had demanded that the building feature exterior lighting at night. This was a requirement tailor-made for architect Arthur Atkinson, whose primary interest was in lighting. Floodlights were placed below the top level and in torch-shaped fixtures just above the first floor, where merchandise was displayed in large show windows. Colored lights were initially used, resulting in a stunning display. Atkinson was well on his way to building a reputation as a modern lighting expert.

Not only was the early headquarters structure a spectacle of light downtown, but the company's power plant, originally located on Cheyenne Avenue north of downtown, has beamed out its location on the west bank of the Arkansas River since 1922 with a sign made up of more than thirty-two

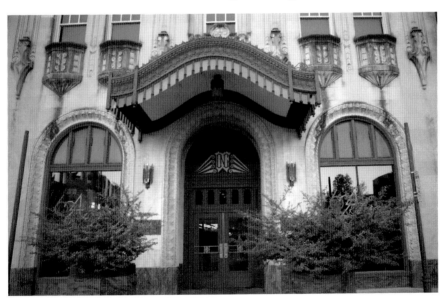

Oklahoma Natural Gas/624 Catering.

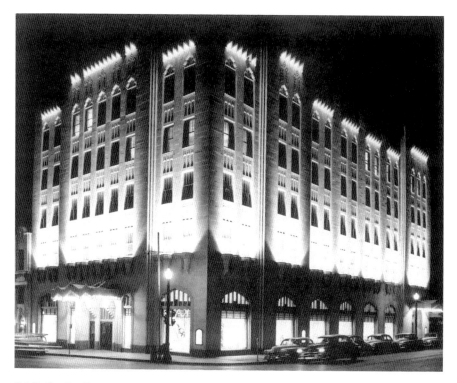

Public Service Company of Oklahoma Building, 1950. *Courtesy PSO.*

hundred red and white bulbs. "Electricity...Public Service Co. of Okla." continues to light up the night sky. After so many years of service, the sign has earned the status of landmark.

In 1978, in need of additional space, PSO played an important role in the preservation of Central High School, another historic downtown building. Constructed in 1917 at the corner of Sixth Street and Cincinnati Avenue, Central was enlarged five years later and in 1938 was recognized as the second-largest high school in the country with an enrollment of five thousand students. Sensitive to issues of preservation, PSO renovated the exterior of the building and made interior changes to accommodate offices. It now serves as the company's headquarters.

Divine Deco (Boston Avenue Methodist Church and Christ the King)

It was the 1920s, high times in Tulsa, the Oil Capital of the World. Young women bobbed their hair and shortened their skirts. Young men considered their cars symbols of freedom. Cigarette sales doubled. Every home had a radio. Couples danced to the beat of the Charleston and swayed to the sensual strains of jazz. Thanks to the continuing flow of black gold, luxurious offices and homes were under construction and businesses were thriving. The neighborhood centered on Tulsa's Greenwood Avenue, known as "Black Wall Street," was one of the wealthiest black communities in the country.

But the good life had its downside as well. Prohibition was enforced, fueling organized crime and the proliferation of bootleggers and speakeasies. Tulsans got around the law and sipped whiskey imported secretly from neighboring states. In 1921, the deadliest race riot the country had ever seen took place when, according to an inflammatory news story, Dick Rowland, a black teenager, allegedly assaulted Sara Paige, a white teenager, in a downtown Tulsa elevator. A vigilante mob backed by the Ku Klux Klan looted businesses and homes in Greenwood, ultimately burning most of the community to the ground. Hundreds of residents were injured or killed and thousands were displaced, their homes and businesses destroyed.[20] The race riot of 1921 subdued the mighty roar of the twenties in Tulsa.

Into this mix of joy and sorrow stepped the pastors of local churches. As they reached out to their members, it was apparent that more room was needed to accommodate their growing congregations. Two of the larger churches were built in the Art Deco style during the 1920s. True to the spirit of the times, one of the churches was caught up in a web of dispute over who should be recognized as the official designer.

Boston Avenue Methodist Church sits on the southern edge of downtown Tulsa. Its location was selected not only for the size of the property but also because three major thoroughfares converged there, making the unusually tall church a central point in the lives of all who worked and shopped downtown. It would stand at the end of Boston Avenue, one of the main streets of downtown Tulsa. Oil barons in their chauffeur-driven limousines and clerks and salespeople in their Ford Model Ts who passed the church on their way home would look up to where the graceful Deco finger pointed to the heavens and be freed from the stress of their day.

The first time you see Boston Avenue Methodist Church, odds are you will take a second look. This is no ordinary house of worship. It reaches skyward like praying hands. It has a modern air that defies the year 1929, when it took its place in the Tulsa skyline. Inlaid sculptures surround the base of the building. The gleaming peak of the tower catches the morning sun on one side and the sunset on the other side. If you stop and take time to look at the church from every angle, you will see that the front door could easily be placed on any of the four sides. In short, Boston Avenue Methodist Church is an architectural wonder.

The controversy surrounding the creation of Boston Avenue Methodist Church might be considered both fortunate and unfortunate. It puts into question who should be credited with the design, leaving members of two opposing schools of thought in conflict. It continues to lend to the story of this Tulsa icon an air of mystery that can't help but add to the wonder of the structure.

In 1925, thanks to a growing congregation, a building committee was formed by the members of the Boston Avenue Methodist Episcopal Church South at Fifth and Boston in downtown Tulsa. C.C. Cole was named chairman of the committee. He and his wife, Audrey, traveled extensively around the country looking at churches. They were not impressed by what they saw. On their return to Tulsa, several architectural firms were interviewed, but again, the steering committee found nothing to their liking. In desperation, Audrey Cole turned to her friend Adah Robinson for help.

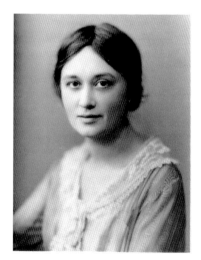

Adah Matilda Robinson had been born in Richmond, Indiana, to a Quaker family. After completing college, she studied at the Art Institute of Chicago. She moved with her family to Oklahoma City, where she taught art in the public school system, and finally, during the years leading up to 1920, she moved to Tulsa.

Robinson taught art at Tulsa Central High School, at one time one of the largest public schools in the nation. Among her students were Bruce Goff and Joseph Koberling, who would go on to become two of the city's leading Art

Adah Robinson. *Courtesy Boston Avenue Methodist Church.*

Deco architects. She was recognized as a teacher, painter and printmaker, but the enduring mark that Adah Robinson would leave is found in the assortment of Deco structures that her former students designed throughout Tulsa.

In 1925, when the church elders grew concerned about the difficulty in determining a design for Boston Avenue Methodist Church, Audrey Cole urged the committee to enlist Adah Robinson. With an eye to the formidable towers of the cathedrals of Europe, Robinson drew a rough sketch of what would ultimately be built. Initially, the drawing shocked the building committee, but after several days of detailed explanation, the art teacher was able to sell her idea.

The Tulsa architecture firm of Rush, Endacott and Rush was hired at the suggestion of Robinson, who was unable to convert her designs into architectural renderings. In the course of communicating her ideas, she worked with her former student Bruce Goff, a draftsman at the firm. In her manuscript detailing the building of the church, Audrey Cole recalled:

> *Too familiar to those of us on the inside was the scene of A.R. [Adah Robinson] seated there in "the Little Gallery" where they worked at first, drawings on her lap, Bruce Goff kneeling in front of her being told to place a line here another there to express what she was seeking. I myself have heard her remind him often during this process "This is a church, not a theater, Bruce."*[21]

Adah Robinson was not an architect. She was, however, a determined artist, and after several months of research about Methodism and the religion's history, she had definite ideas of details she wanted to be incorporated into the design of the church. She was also aware of the desire of the pastor, Dr. John A. Rice, to abandon the old architectural forms used in Europe in favor of "a new set of symbols." He wanted a building that would, in his words, "talk to me in the rain." According to Adah Robinson:

> *Modern religion is vital and of continuous growth; therefore, the place of worship should not be final, ominous, conscious of wealth or temporal power, but by a vertical dominance of line suggest the open mind. Closed lines and horizontal lines have been associated with finality. Modern lines are upward, open and free. Hence the design of the finials, the praying hands. The closed clasped hands of the Middle Ages signify the intensity and fear of the supplicant. These modern hands, open, are confident of the receptivity of Divine Grace.*[22]

Boston Avenue Methodist Church, mosaic.

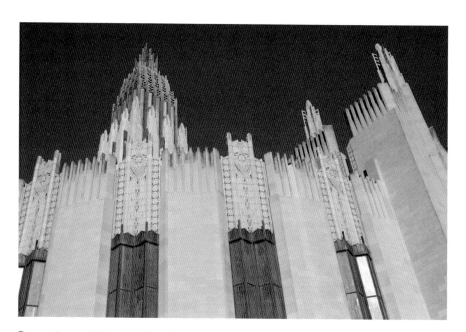

Boston Avenue Methodist Church.

Bruce Goff, circa 1920. *Bruce Goff Archive, Ryerson and Burnham Archives, The Art Institute of Chicago. Digital File # 199001_160229-001.*

Bruce Goff, the exceptional young architect at Rush, Endacott and Rush, worked hand in hand with Robinson to translate her ideas into architectural blueprints and to add to her original design of a central spire Art Deco elements that would set it apart from European cathedrals.

In a 1926 newspaper article announcing the project, the headline stated, "Bruce Goff, 22, Plans Boston Avenue Temple: His Teacher Aids." The news story went on to explain "it was through the pencil of the youthful Goff, associated with the local firm of Rush, Endacott, and Rush, that his instructor's creation became a living thing."[23]

When the church was designated a National Historic Landmark on January 20, 1999, the registration form described the architect/builder as "Goff, Bruce, architect; Robinson, Adah, designer; Garrison, Robert, sculptor."[24]

In spite of any controversy surrounding whom to credit for the creation of Boston Avenue Methodist Church, both Robinson and Goff brought new design elements into play, making the place of worship a piece of art unusual in both its soaring exterior and its circular interior.

"When the finished structure received international acclaim, the architectural firm tried to take credit. The building could not have been built without the expertise of his firm—they gave it a body. But Adah Robinson gave it a soul."[25]

Robinson, whose dream was to make the project as native to Oklahoma as possible, chose the symbols of two flowers to appear throughout the church, in stone, wood and glass. She explained her choice of flowers:

> *The tritoma or torch lily is indigenous to this state. It grows in shadowed places, a flower of flaming color with a strong stem which suggests organization. The clustered blossoms growing downward are suggestive of the generosity of this faith. The coreopsis is prolific in the hardest soil. Its brilliant blossoms give color to the waste places of Oklahoma.*[26]

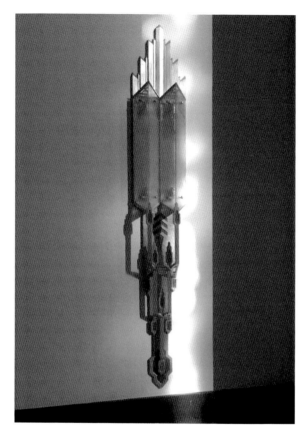

Left: Boston Avenue Methodist Church, sconce.

Below: Boston Avenue Methodist Church, sanctuary.

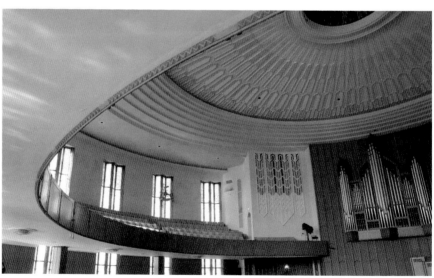

Years later, Goff would explain:

> *I remember when I did the Boston Avenue Church in Tulsa, Oklahoma, in 1926, I had a circular auditorium. This was considered very irreligious and downright sinful. I won't say why, but anyway it was. It also had a driveway entrance to the church and this was considered sacrilegious. You were supposed to suffer and walk through the rain from where you parked. You were supposed to sit on hard pews instead of a comfortable seat. All in the name of religion. That's all right for those who want it.*[27]

Goff previously had worked with Barry Byrne on Christ the King, a church commissioned by Bishop Francis C. Kelley on a block of residential property in Tulsa. Byrne had been apprenticed to Frank Lloyd Wright in 1902 for five years and had traveled abroad to study European architecture. Bishop Kelley wanted a modern church, but one that would fit the needs of Catholic worshipers. Byrne, familiar with the cathedrals of Europe and schooled in Wright's early designs, was the ideal architect to carry out the bishop's wishes.

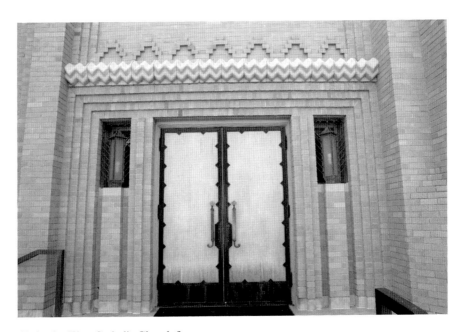

Christ the King Catholic Church front entry.

Christ the King was not designed in the traditional religious shape of a cross. Like Wright, Byrne based the form of his design on the function of the structure. Thus, the church was designed in a semicircle around the main altar, which housed the Holy Eucharist, the focus of worshipers.

Byrne preferred working with bricks. Art Deco design is apparent in the decorative topping to the Gothic-like spires and in contrasting bricks on the interior walls. Goff designed the ceramic mosaics for the side altars, the church furniture, the bishop's throne and the priest's bench. Alfonso Iannelli, who assisted in the overall design of the church, created the side altar statues of St. Joseph and the Blessed Virgin, as well as the terra-cotta ornaments on the outside finials. Iannelli and Edgar Miller collaborated on the stained-glass windows.

The managing editor of *Liturgical Arts* magazine described Christ the King Church as "a refreshing departure from the stereotyped structure.... The buildings certainly fit into the American landscape....These windows rank among the best to be found in the United States....[They are] superb in color and design."[28]

There would be no controversy later about who designed the church. The first in the world to be dedicated to Christ the King, the church was the result of artists, designers and architects working together in harmony. That might account for why it was completed in 1927, prior to Boston Avenue Methodist.

Bishop Kelley, familiar with the impressive work of Barry Byrne in Chicago, selected the firm Byrne and Ryan to design Christ the King Church. Client and architect worked together, bringing to fruition an idea conceived by the client in a manner only the architect could complete. Byrne was older, an established designer of ecclesiastical buildings and a partner in his firm.

Adah Robinson, familiar with the impressive talent of her former student Bruce Goff, selected the firm where he worked, Rush, Endacott and Rush. Goff was young, only beginning to establish his reputation, and would be named a partner in his firm as a result of work done on Boston Avenue Methodist Church.

Perhaps the controversy that arose regarding the designer of Boston Avenue Methodist came about because the young Goff's relationship with Robinson was first and probably always would be that of student and teacher. Goff needed credits to his name. Robinson, a professional woman in the 1920s, accustomed to being overlooked in the business world of men, demanded credit for what she had legitimately first

Right: Christ the King Catholic Church, priest's bench.

Below: Christ the King Catholic Church finials.

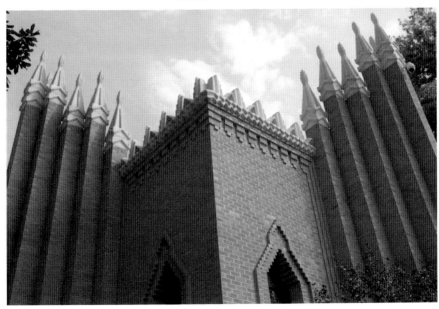

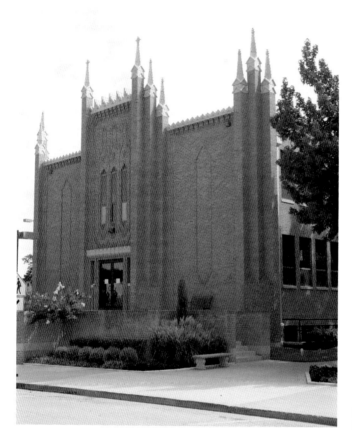

Christ the King Catholic Church.

sketched and oversaw during construction of the church. Both were artists, able to communicate in their particular professional terms. Both had reason to claim the title of designer. It is their misfortune to have ended up enemies. It is our good fortune that they worked together to create Tulsa's most iconic Art Deco treasure.

Eleventh Street Bridge

Constructed in 1916, the Eleventh Street Bridge—known today as the Cyrus Avery Route 66 Memorial Bridge—is a continuous span of uniform concrete roadway and guardrails. The eighteen arches incorporated

into the design were enhanced in 1929 when the original Victorian-style guardrails and lights were replaced by balustrades and lighting fixtures with Zigzag and PWA Art Deco motifs.

Oil was first discovered in the Tulsa area on June 24, 1901, on the west side of the Arkansas River, not far from the small village of Tulsa on the east side. Word of the first strike brought hundreds of people to the area within days, and the search for black gold was underway in earnest.

New residents pouring in from other states brought with them the need for lodging, dry goods and groceries and cultural venues for their families. The logical place where their needs could be accommodated were the nearby west-side communities of Red Fork and Sapulpa. However, several progressive Tulsa leaders saw an unprecedented opportunity and proposed construction of a wagon bridge to transport workers across the Arkansas River.

The proposition lost when put up for a vote, but three determined Tulsans with ties to brickmaking, banking and construction—M.L. Baird, George T. Williamson and J.D. Hagler—joined efforts and completed the project with private funds. On January 4, 1904, the bridge was opened with a plaque at the entrance stating, "You said we couldn't do it, but we did."

It was perfect timing. In 1905, a gusher discovered on the Ida Glenn farm led to a string of successful strikes along an eight-mile stretch of land considered "the richest little oil field in the world" by 1930.[29] Tulsa was fast becoming the headquarters town, providing offices and residential neighborhoods for oil barons and their families.

On February 26, 1915, Cyrus Stevens Avery, chairman of the board of county commissioners for Tulsa County, proposed that money be raised to replace the well-worn wagon bridge. Tulsans did not hesitate this time and voted in favor of the construction of a reinforced-concrete bridge across the Arkansas River. When it opened in 1916, the Eleventh Street Bridge was one of the longest concrete structures in the Midwest.

At the 1924 annual meeting of the American Association of State Highway Officials, Cyrus Avery, who by then was highway commissioner of Oklahoma, was a member of a board appointed to lay out and create what would be known as the United States Highway System. As a result, U.S. Route 66 was designated the primary passage between Chicago and Los Angeles. Knowing that the highway would need to cross the Arkansas River on its way through Oklahoma and that the Eleventh Street Bridge provided that access, Avery made certain the highway would make its way through Tulsa. He soon became known as the "Father of Route 66."

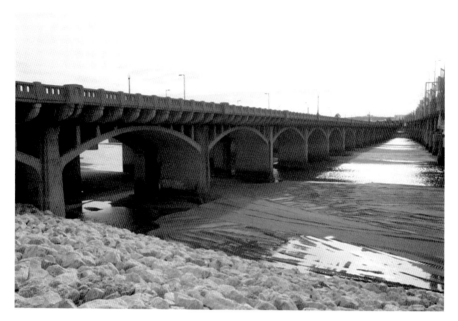

Eleventh Street Bridge (Route 66).

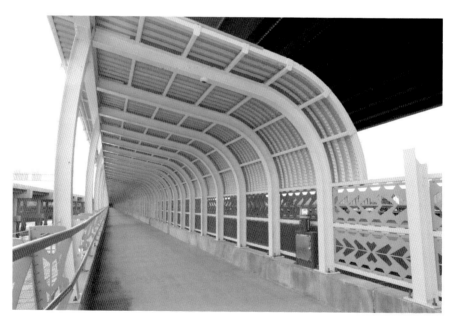

I-244 bike/pedestrian trail, Art Deco design patterns.

After sixty years of service, the bridge was closed, and a new bridge was completed in 1981. A gate restricts vehicles and pedestrians from using the old bridge, but at the nearby Cyrus Avery Centennial Plaza, travelers can still see where "East Meets West" on Route 66.

HALLIBURTON-ABBOTT BUILDING

The Halliburton-Abbott department store that opened at Fifth Street and Boulder Avenue just weeks after the Wall Street crash of 1929 was the first department store in Oklahoma with central air conditioning and was touted as the finest structure of its kind in the Southwest. The building, designed by architect Frank C. Walter, had an exterior faced in buff terra cotta. It was considered a prototype of the Zigzag style.

When the owners unveiled their plans, they predicted that the building would be a "monument to the progress of Tulsa as well as a monument to the confidence and goodwill of the people."[30]

Unfortunately, "confidence and goodwill" went only so far. Only two years after opening, Halliburton-Abbott Company fell victim to the Great Depression and went out of business. Sears, Roebuck and Company leased the building in 1931 and stayed until 1958, when Sears became the first major department store to flee downtown for the suburbs. Skaggs drugstore took over the first three floors of the building in 1961.

Halliburton-Abbott Building architectural relics.

In 1980, despite cries of protests from many in the general public as well as the architectural and preservation communities, the finest remaining Deco commercial building in Tulsa was unceremoniously demolished, along with other historic structures, by Cities Service Company, later renamed CITGO. The site was chosen for a new fifty-two-story headquarters, which was intended to be the tallest building in the state.

That never happened. Plans were derailed when CITGO left Tulsa and moved its headquarters to Houston because of changes in ownership. Then in 1982, Oklahoma Natural Gas Company, headquartered in one of Tulsa's earliest Art Deco buildings, scrapped its plans to replace the historic namesake edifice that had served as ONG's home since 1925. Instead, ONG moved into the partially completed CITGO high-rise. ONG, then named ONEOK, took over the building and halted construction at the seventeenth floor. The ONEOK tower of black granite and glass was completed in 1984.

Riverside Studio (Spotlight Theatre)

There was a song in his heart when Bruce Goff designed Riverside Studio.

Known today as Tulsa Spotlight Theatre and located near downtown on the corner of Riverside Drive and South Houston Avenue, the Art Deco building originally was intended to serve as studio, auditorium and home for Patti Adams Shriner. She taught piano lessons in three separate studios built, along with practice rooms, above the front entry. Students performed recitals in the auditorium below. Shriner's dining room, kitchen and pantry were located off the left side of the stage. Her master bedroom and two other bedrooms stacked above it were to the right of the stage.

Built in 1929, Riverside Studio was one of Goff's early designs. As evidenced in his later work, he created an environment that fit comfortably into the landscape and reflected the persona of the individual for whom it was built. Drive by the stair-step series of white stucco blocks built on a steep hill, and you will see music.

Spotlight Theatre.

Goff, who as a youth had considered a career in music, loved Debussy, Bartók and Stravinsky. Perhaps Goff composed a musical score as he designed the front of Riverside Studio. Rhythm is captured there. In keeping with the large round window featuring a decorative pattern reminiscent of piano keys, the small rectangular windows interspersed with black tiles look like holes in the rolls of old-time player pianos.

Attention was called to the original entrance by a fountain designed by Alfonso Iannelli, an Italian-American sculptor, artist and industrial designer with whom Goff worked on several buildings, including Boston Avenue Methodist Church.

To enhance the musical motif of Riverside Studio, pipes dripped water into chromium cups of different sizes, creating music as their contents cascaded into the pool below.

Black glass and green marble fireplaces and Japanese wall coverings made from wood veneer were among the elegant touches gracing the interior of the studio. Goff also hired Olinka Hrdy (pronounced Her-dee) a half-Czech, half-Sac and Fox Indian artist, to paint a series of nine murals representing musical themes. Like Goff, Hrdy appreciated Native American art and bright colors. Her abstract murals appeared at the entry of the studio and in the recital hall.

Although Goff designed a music studio, the relationship that developed between Patti Adams Shriner and Olinka Hrdy was anything but music to his ears. The two women, each of whom considered herself an authority, lashed out at each other. They argued incessantly about the colors to be used in the murals. Shriner declared that Hrdy's use of green and red was indicative of envy and hate. Hrdy contended that perhaps Shriner should use only white, the color of insanity. It was Hrdy who had the last laugh when she formed the word *jazz* with small triangles in one of the murals. Shriner, a classically trained pianist, hated jazz.

According to Scott Pendleton's article in *This World*, when Shriner opened her school in 1929, "the *Tulsa World* wrote a glowing account of Shriner's building and the artworks inside. The Chamber of Commerce featured an exterior photo in its publication under the headline 'Much of Tulsa's Beauty Is the Gift of Those Who Built for Business.'"

Because Riverside Studio was so uniquely designed and progressively modern—especially obvious given its location next to the Gothic Revival McBirney Mansion, also built in 1928—Shriner's home drew a great deal of attention. Gawkers continuously knocked on her door asking to be shown through the studio. This irritated and infuriated the piano teacher,

Riverside Studio, circa 1928. Bruce Goff, architect. Paul Stitem, photographer. *Bruce Goff archive, Ryerson and Burnham Archives, The Art Institute of Chicago. Digital File # 199001. Riverside_1.*

who instead of being asked to enroll visitors as students was being asked to conduct tours.

Bruce Goff suggested that she use these intrusions as opportunities to introduce would-be pianists to the value of taking lessons. However, what resulted was that Shriner became jealous of the attention her studio was getting, and the other teachers in her studio found her increasingly difficult to work with. Finally, victim to her own self-esteem and the economic ravages of the Great Depression, Patti Adams Shriner lost Riverside Studio to the mortgage company in 1933.

Riverside Studio sat empty until Holland Hall, a private preparatory school, leased the building for five years to use as classrooms. In 1941, drama teacher Richard Mansfield Dickinson purchased the building for an elocution studio. After his retirement, he was offered a goodly sum for the studio but fortunately, declined to sell it, fearing that it would be demolished.

In 1953, Dickinson allowed the Spotlighters, a small group of local actors, to present a melodrama performance they had previously offered in a second-floor downtown restaurant. Expecting to use the auditorium for only a short run, the actors instead found themselves in demand as the public

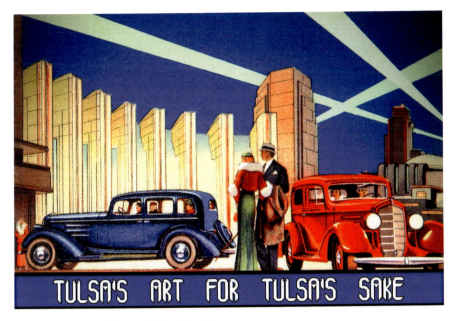

Art Deco postcard. *Courtesy William Franklin.*

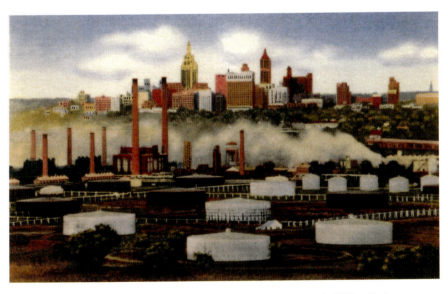

Mid-Continent Oil Refinery and Skyline of Tulsa, vintage postcard. *Wallis collection.*

Decopolis postcard. *Courtesy William Franklin.*

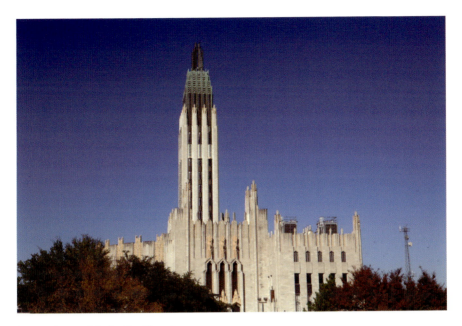

Boston Avenue Methodist Church.

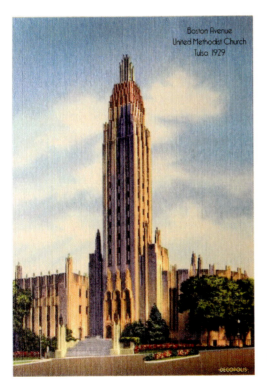

Boston Avenue Methodist Church, vintage postcard. *Wallis collection.*

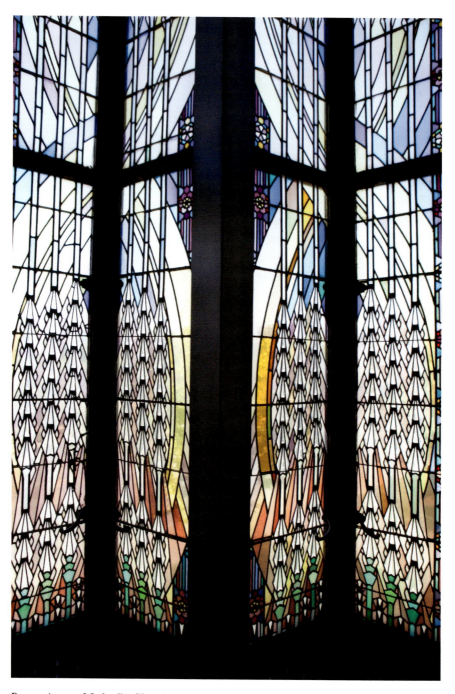
Boston Avenue Methodist Church, stained-glass window.

Left: Oklahoma Moderne Olinka Hrdy exhibit catalogue. *Courtesy Jamie Townsend.*

Below: Patti Adams Shriner, House and Studio, number 2, Tulsa, OK: Presentation Plan: "Patti Adams School of Music, Studio & Home," 1928. *Bruce Goff Archive, Ryerson and Burnham Archives, the Art Institute of Chicago. Digital File # 19001_16115-007.*

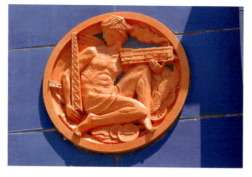

Left and middle: Warehouse Market façade detail.

Bottom: Westhope.

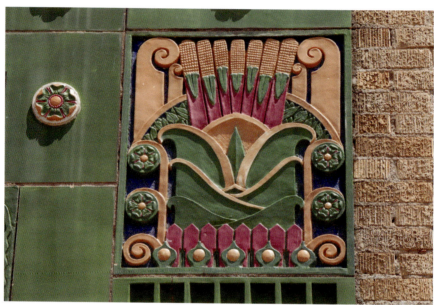

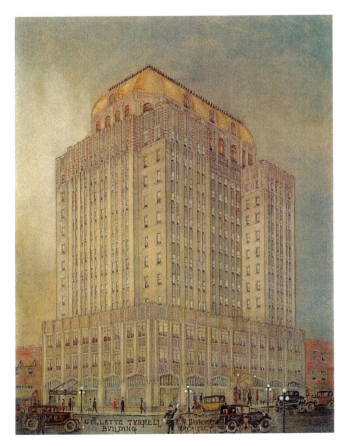

Gillette-Tyrrell Building (Pythian), 1929 rendering. *Courtesy Brad Buffum.*

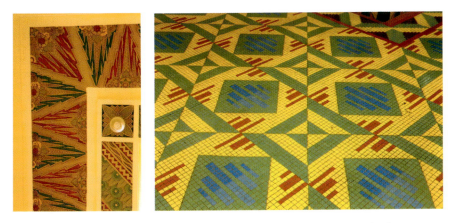

Left: Pythian Building lobby ceiling pattern detail. *Right*: Pythian Building lobby floor pattern detail.

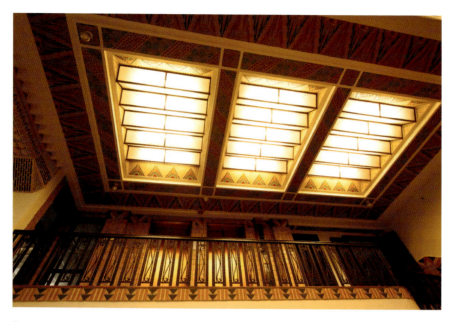

Pythian Building lobby skylight.

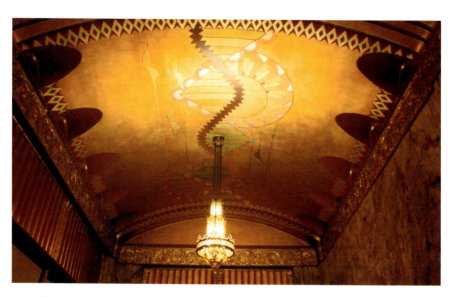

Philcade Building lobby gold-leaf ceiling.

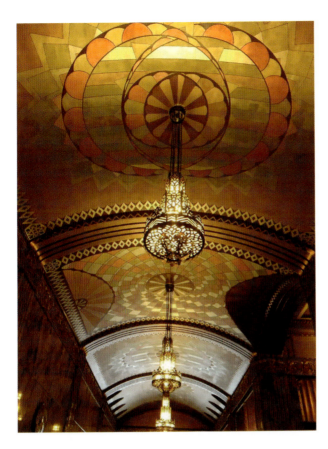

Left: Philcade Building lobby chandeliers and geometric designs.

Below: Tulsa Municipal Airport, vintage postcard. *Wallis collection.*

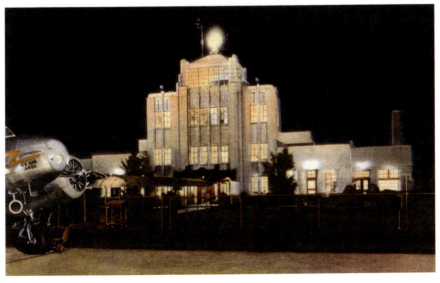

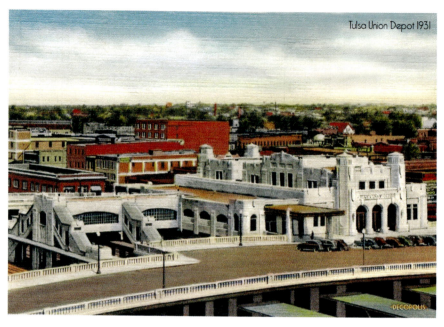

Tulsa Union Depot 1931, vintage postcard. *Wallis collection.*

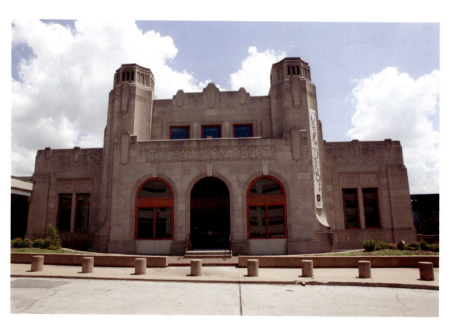

Tulsa Union Depot.

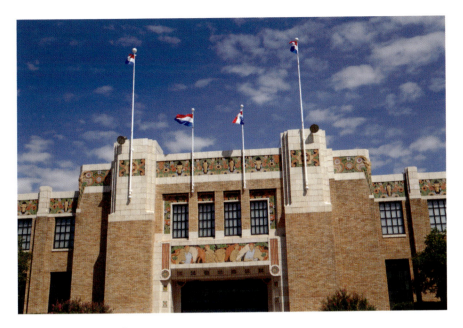

Tulsa Fairgrounds Pavilion.

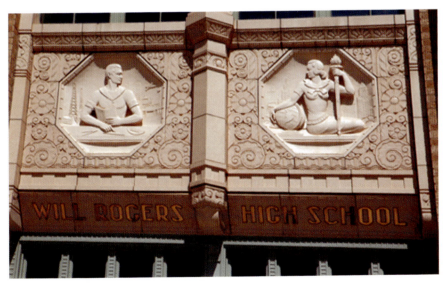

Will Rogers High School entry.

Left: Art Deco Museum puppets display.

Below: Day and Nite Cleaners.

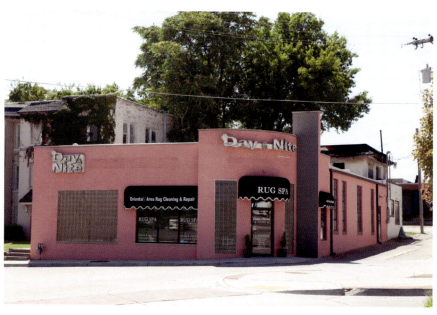

Right: Tulsa Monument Company clock tower.

Below: Myers-Duren Harley-Davidson. *Courtesy Reba McClanahan.*

Above: Tulsa Art Deco Museum postcard. *Courtesy William Franklin.*

Left: Tulsa Art Deco Museum, "Deco Debby" collection items.

Tulsa Art Deco Museum merchandise display.

Mural, downtown Tulsa.

Above: Art Deco figurines at Decopolis.

Left: Goddess of Oil. *Courtesy William Franklin.*

Spotlight Theatre lobby interior.

flocked to Riverside Studio. Ultimately, the group purchased the building in 1964 and christened it the Spotlight Theatre.

You might want to cruise by Spotlight Theatre, a whimsical creation by Oklahoma's most daring architect. Consider the history of the building. Make reservations for an evening at the dinner theater and enjoy a performance of *The Drunkard*, the longest continually running play in North America, performed at the Spotlight since November 14, 1953. You will have a chance to sing along to some of your favorite old-time songs before booing and hissing at the villain and cheering on the hero. The melodrama is followed by the Olio, a one- or two-act variety show featuring local talent, some of whom have gone on to national prominence.

No matter what you do, take the time to notice the disrepair of this historic Tulsa icon. Weather has eroded the stucco. There is only a suggestion of Iannelli's lovely fountain, sitting amid flowers and bushes. The Olinka Hrdy murals have disappeared. But you should consider that this is, as Goff intended, "music frozen in architecture." It speaks to the very quality that makes Tulsa a city rich in design of every sort. And if you doubt that this Art Deco treasure should be saved, ask to see the hundreds of signatures on the walls behind the stage. Actors have left these over the years as stamps of their love for a place where they have brought joy to so many people.

Warehouse Market

During the late 1920s and early 1930s, architect B. Gaylord Noftsger, one of the first licensed architects in Oklahoma, designed two stylish markets—one in Tulsa, Oklahoma, in 1929 and the second in Fort Worth, Texas, the following year.

Built on the site of McNulty Park, the historic brick building in Tulsa features bright terra-cotta touches on the entry tower and along the top of the parapet. On each side of the blue tiled doorway is a red medallion reminding shoppers about the history of their city. A goddess holding a cornucopia and sheaf of wheat is contained on one medallion, and the other portrays a helmeted god holding an oil derrick and train engine.

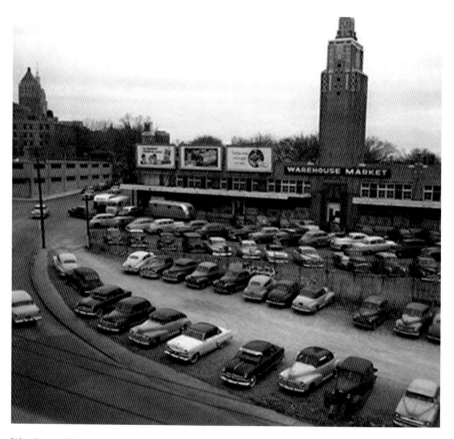

Warehouse Market. *Courtesy Tulsa Historical Society.*

This page: Warehouse Market entry detail.

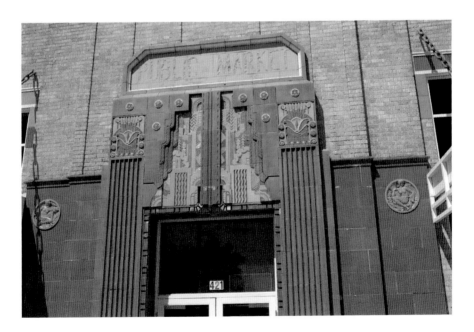

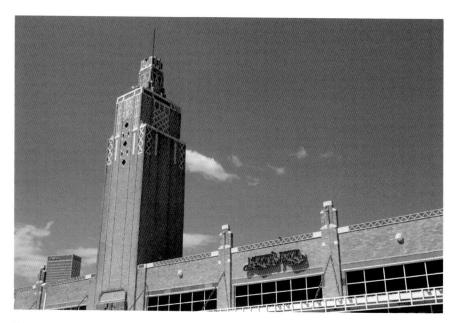

Warehouse Market tower.

The market was a hub of activity when it opened. Colorful displays of produce, fragrant flower stalls and a butcher's department offering fine cuts of meat provided a complete selection of groceries. Not only were shoppers entertained by live country music, but they also could take advantage of the services of a barbershop and beauty shop and dine at a restaurant and snack bar.

A victim of the Great Depression, Warehouse Market suffered the loss of customers. During the 1930s, it abandoned the sale of groceries and became an entertainment center featuring Benny Goodman, Duke Ellington and Cab Calloway. By 1938, groceries were again on sale. After the end of prohibition in Oklahoma twenty years later, a liquor store opened in the market building.

Eventually, the market became a discount center until Home Depot bought the rundown structure in the late 1980s. Although the new construction threatened to demolish Warehouse Market, Home Depot agreed to preserve the frontage of the building and construct in the rear of the property what became a successful Home Depot downtown center.

Of the various stores opened in the frontage retail space, a restaurant and a liquor store hark back to the early days of Tulsa's Warehouse Market.

Westhope

"The damn thing's more beautiful than I ever imagined,"[31] exclaimed Frank Lloyd Wright when he first saw Westhope, the home he had designed for his cousin Richard Lloyd Jones.

Jones, when he visited the site during construction, thought it looked like a pickle factory. "Do they have to build them like this?" he asked.[32]

After moving in, the Jones family—Richard, Georgia and their three children—frequently had to place buckets and pans around the living room to deal with the leaking roof. When water began to drip onto his built-in desk, Jones called his cousin and complained. Wright responded by telling him to move the desk. Georgia Jones, with a hint of Irish humor, declared, "Well, this is what we get for leaving a work of art out in the rain."[33]

Named for the family's ancestral home in England, Westhope, which means the west slope of a hill, was built in 1931 on land that was then just outside the Tulsa city limits. Known for his Prairie-style designs, Wright decided to deviate from his preliminary sketches of a wood-and-stucco structure with horizontal bands of windows that would blend into the flat landscape of the area.

Instead, he designed a multilevel house with alternating vertical columns of glass windows and stacks of concrete blocks that were the result of one of Wright's experiments. The blocks, created on site, were made of a "textile" type of material that unfortunately let moisture in, another source of dampness the residents would have to endure. A geometric relief is integrated into the blocks, adding to the distinctive appearance of the home.

Richard Lloyd Jones and Frank Lloyd Wright were cousins, members of a close family, always at the beck and call of each other when needed. As children, they had spent summers together on the family farm in Wisconsin. In later years, in spite of differing political views and frequent arguments, the two remained friends.

In 1914, Wright's Taliesin home was set on fire after his mistress, her two children and four other people were murdered. The architect had been the subject of scandal earlier in Chicago after he abandoned his wife and six children. Frequently broke, the infamously arrogant Wright had been rescued financially by Jones, who again reached out in 1929 to lend a helping hand when he hired his cousin to design a new residence.

Westhope took longer to build and cost more than expected at a time when both Jones and Wright faced the financial risks of the Great Depression. The result, composed of five bedrooms, four and a half baths,

five fireplaces and a five-car garage, includes a lap pool, cabana, fountain, fishpond and light fixtures designed by Wright.[34]

Grandchildren delighted in playing on the spacious grounds at Westhope, the scene of frequent family gatherings. But in 1931, the iconic Art Deco home made the news when Captain Lewis Alonzo Yancey landed a helicopter in the driveway during a cross-country advertising tour for Champion Spark Plug Company.[35]

Since 1963, Westhope, listed in the National Register of Historic Places, has been cared for by subsequent owners who have made minimal changes. It is one of only three Frank Lloyd Wright buildings in Oklahoma.

"Though no longer owned by the Jones family, Westhope remains big. And magical and dramatic.

"Truly a Tulsa treasure."[36]

Gillette-Tyrrell Building (Pythian)

As Tulsa boomed during the 1920s, examples of Art Deco architecture popped up like oil derricks all over town. The eye-catching Pythian Building at Fifth and Boulder would have been the crowning glory of the early architectural movement but instead became a casualty of the times.

A pair of local oil tycoons turned real estate entrepreneurs—James Max Gillette and Harry C. Tyrrell—joined forces in 1930 to underwrite the construction of the Gillette-Tyrrell Building, designed by Edward Saunders. Specialty shops, including Ben Estes Clothing, Trimble Flower Shop and the French Boot Shop, as well as Western Union Telegraph, were among the tenants on the first three floors of what was originally designed as a thirteen-story hotel. The owners were forced to scale back their plans when the Depression intervened. Both Gillette and Tyrrell suffered from the stock market crash, and although they eventually recovered some of their losses, the decision was made to divest some of their holdings. In 1931, the Gillette-Tyrrell Building was sold to the Knights of Pythias, a benevolent association that held meetings in the basement, which was also used for cold fur storage. The building soon became better known as the Pythian Building.

The Pythian's façade—a mixture of multicolored terra cotta, marble and granite—is striking, but the L-shaped lobby remains the most notable feature. Along with a mosaic floor design taken straight from Native American motifs, the lobby features colorful tiles, intricate plasterwork,

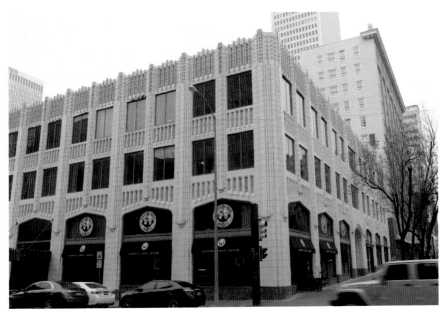

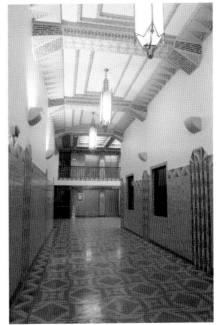

Top: Pythian Building. *Bottom, left*: Pythian Building entry ceiling. *Bottom, right*: Pythian Building lobby hallway.

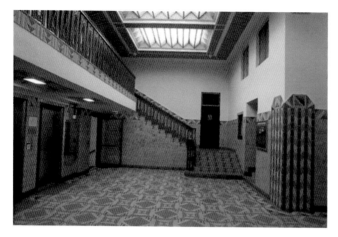

Pythian Building lobby.

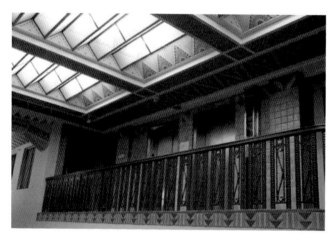

Pythian Building lobby cast-iron railings.

Pythian Building lobby ceiling detail.

custom cast-iron railings, etched-glass windows and classic Art Deco light fixtures.

Over the years, the building received design and architectural awards and in 1982 was described by the National Register of Historic Places as "one of the finest examples of early Art Deco architecture in a city internationally known for that style." Despite some periods of vacancy, a series of owners invested in necessary restoration and repairs of the historic structure, including in 1980 a $2 million update of the roof, windows and electrical system.

"People from across the country come to see this building because of its zigzag style of Art Deco," the late Rex Ball, internationally known architect and member of the Tulsa Preservation Commission, told the *Tulsa World* in 1999. "Its symbolism of Native American motifs makes it one of a kind."[37]

Milady's Cleaners (La Maison, Inc.)

Opened in 1930 on Eleventh Street (aka Route 66) in a striking two-story Zigzag Art Deco building, Milady's Cleaners catered to the upper echelon of Tulsa society.

The buff-colored terra cotta covering the ground floor blends seamlessly with the cream-colored stucco of the second story. Sculpted terra-cotta designs of flora and fauna, including leaping stags, surround the windows.

Soon after Milady's opened, the owners developed a close working relationship with Miss Jackson's, Tulsa's premier department store for wealthy female shoppers. During the hot summer months in Oklahoma, Miss Jackson's elite clientele and other customers throughout the region flocked to Milady's to store their valuable furs in the two spacious climate-controlled vaults in the basement. A handy underground spring was used in the cleaning process.

Although Miss Jackson's no longer exists and Milady's Cleaners has been closed for many years, the building continues to serve the public and help illuminate the city as La Maison, a retailer offering custom lamps and chandeliers. Behind the substantial green-and-gold door of the remaining cold-storage vault, hundreds of patterns and designs for lighting fixtures are housed.

Philcade

During the late 1920s and early 1930s, Waite Phillips, the quietly aggressive oil tycoon and younger brother of Frank Phillips, founder of Phillips Petroleum Company, built two of downtown Tulsa's major office buildings, at the corner of Fifth Street and Boston Avenue.

In 1927, Phillips constructed the Gothic-style Philtower, complete with its striking green-and-red polychrome tile roof. As was the custom of the time, he purchased the land across the street so he would have control of what might be built facing the entry of the Philtower. That proved to be a wise decision.

In 1928, merchants' leases along Tulsa's Boston Avenue were beginning to expire. Phillips was concerned that some owners might consider moving to the west, along Boulder Avenue, resulting in the growth of downtown Tulsa changing direction away from his property. To ebb the flow of retail away from Boston Avenue, Phillips commissioned Leon B. Senter, a young architect with whom he had become acquainted in Okmulgee, Oklahoma, to construct a building with space for shops on the site across from the Philtower.

Ground was broken in 1929 for the Art Deco Zigzag-style Philcade Building, completed in 1931 and designed to complement the Philtower. In fact, the entrances to both buildings are perfectly aligned. To satisfy the need for retail space, several shops were located on the ground floor and mezzanine of the Philcade, including a cigar store, newsstand, barbershop, drugstore and ladies' clothing stores, among others. Financial firms and real estate brokers occupied the second floor.

The most difficult construction problem came when miners were hired to dig an eighty-foot brick-lined tunnel connecting the Philcade to the Philtower just across Fifth Street. The tunnel was built to provide ease in moving supplies from one building to the other and for additional underground storage. It also provided safe passage between the two buildings during an age when robbing and kidnapping wealthy oilmen and their families were endeavors for savvy criminals. The tunnel was the first of many that ultimately would connect several other important structures in downtown Tulsa.

Although original plans for the Philcade had called for no more than two stories, during construction, Phillips decided the appearance of the building would be improved by adding ten floors for office space, most of which would be leased to oil companies. A recessed area between the two office

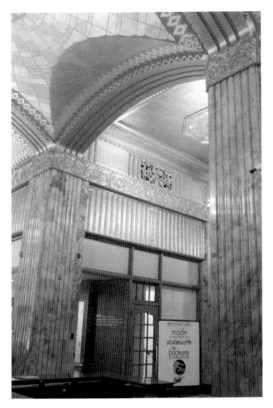

Left: Philcade Building lobby.

Below: Philcade lobby ceiling.

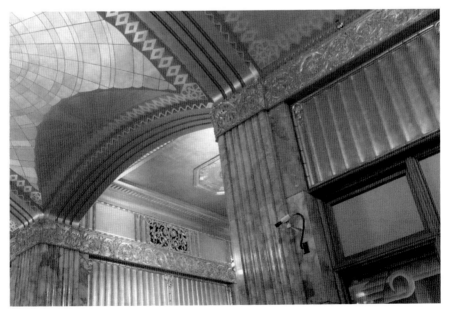

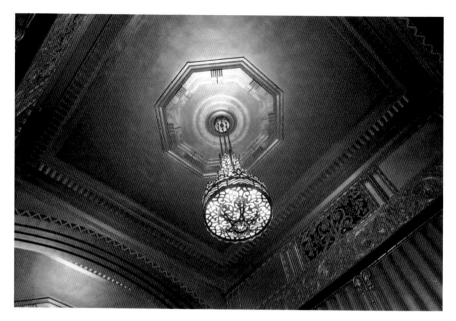

Philcade lobby chandelier.

wings provided additional light and ventilation. Ultimately, the Philcade offered the most office space in Oklahoma at that time.

The final touch, in 1937, resulted in the Philcade emerging as Tulsa's standout downtown skyscraper. A twenty-three-room penthouse was added as a residence for Waite and Genevieve Phillips, and space was provided for what was to be the city's first air-conditioning system. The expansion was praised in the *Tulsa World* as "lifting the few remaining Depression clouds that lingered on the Tulsa business horizon."

The Philcade name stemmed from Phillips's surname and a pair of wide arcades, fashioned of Saint Genevieve marble, that opened onto Boston Avenue and Fifth Street. It is worth noting that the name of the marble used was also the name of Phillips's wife.

Above the lower-floor windows, reptiles, birds and mammals are hidden in the terra-cotta foliage. In the marble hallways of an arcade shaped in a T for Tulsa, the lavish Philcade lobby features classic examples of Art Deco everywhere, from the floral-designed grill that covers the heat register to elegant, custom-made bronze filigree chandeliers and an arched ceiling trimmed in gold leaf highlighted with hand-painted geometric designs.

In 1939, Waite and Genevieve Phillips took up residence in the luxurious streamlined penthouse apartment on the top floor of the Philcade after

giving the city of Tulsa their palatial residence, Villa Philbrook, now Philbrook Museum of Art. Phillips explained his many acts of philanthropy with the words, "The only things we keep permanently are those we give away."

Tulsa Municipal Airport

In 1932, there were five airports in Tulsa when Frederick Kershner designed the handsome Art Deco building that would become the city's primary air terminal. The Zigzag-style structure replaced a single-story wooden "warehouse" with taxiways and landing strips of mown grass that had claimed to be the busiest airport in the world when it handled 9,264 passengers in April 1930.

Early aviation photography graced the walls of the new terminal and pilots' hotel, dubbed Ye Slippe Inn. It was appropriate décor for what became a popular stopover for early aviation pioneers traveling across the country. Among the heroes who landed in Tulsa to pay respects to the Oklahoma aviation financiers were Amelia Earhart, Wiley Post, Will Rogers and General Billy Mitchell.

PUBLIC WORKS ADMINISTRATION

Tulsa Union Depot

Sixty thousand people attended the opening of the Tulsa Union Depot on May 13, 1931. The monumental PWA structure built by Manhattan Construction Company in downtown Tulsa united the three railroad lines—Katy, Santa Fe and Frisco—that had been operating separately in the city. For a brief time when travel by rail was popular, as many as thirty-six passenger trains provided daily service to what was considered one of the most modern passenger terminals in the nation.

The $3.5 million depot, designed by R.C. Stephens, represented the strength and endurance needed to cope with the impending losses sure to be suffered during the Great Depression. A series of sunbursts, chevrons and winged wheels symbolized future hope.

Amenities on the main level included a travelers' aid service, newsstand, barbershop, coffee shop and drugstore. In keeping with the times, entrances, waiting rooms and restrooms were racially segregated.

The construction of the Tulsa Union Depot provided jobs at a critical time and was completed in less than two years. It became a point of pride for Tulsans for four decades.

After travel by rail was diminished by the popularity of airline service and superhighways, the depot was closed in 1967 and stood idle. It had been hailed as the city's most magnificent improvement when it was opened in 1931. Fifty years later, it again became a pivotal element in the

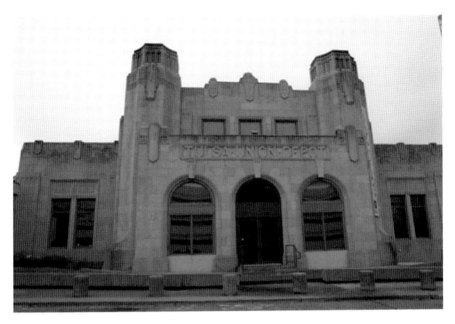

Tulsa Union Depot.

improvement of the surrounding area when it was purchased by Williams Realty Corporation to be restored.

According to Joseph H. Williams, then chairman of the board of the Williams Company, "When the renaissance that has been underway in downtown Tulsa for several years now is complete, I'm personally confident that the Tulsa Union Depot is going to stand out as a jewel—a continuing historic landmark well worth all of the effort that will have gone into it."

Manhattan Construction Company, the original contractor in 1929, was named general contractor for the restoration. Urban Design Center was hired as architect for renovation of the interior into office space, carefully restoring walls, moldings and medallions on the ceiling to their original colors. Both companies became tenants when work was completed in 1983. Continuing rehabilitation of the building took place after the two companies moved, and Tulsa Union Depot became home to the Oklahoma Jazz Hall of Fame.

"The restored Tulsa Union Depot represents the most significant restoration of its kind in the United States,"[38] said Barbara Baer Capitman, founder of the Miami Design Preservation League. Capitman summarized the importance of Tulsa Union Depot when she attended the reopening

This page: Tulsa Union Depot façade detail.

ceremonies in 1983: "Tulsa's Union Depot is what historical renovation projects ought to be. Your project is exactly what people should see in preservation work in the future. Its combination of private, state, and city government interests and good design are fascinating."[39]

Tulsa Fire Alarm Building

Take time to walk around the Tulsa Fire Alarm Building near downtown Tulsa. The PWA structure played a major role in protecting the safety of Tulsans for fifty years. Designed by Frederick Kershner, the PWA building was constructed in 1931 in Central Park according to regulations that specified it be located a prescribed distance from nearby buildings as a safeguard from other fires. However, before it was opened in 1934 to house the best alarm system available, a network of wires and cables had to be installed as hookups to a citywide system of alarm boxes. When a fire broke out anywhere in Tulsa, it was reported by activating a nearby alarm box. A signal was sent to the Fire Alarm Building, where a paper tape was punched with the number of the fire alarm box making the call. Firemen at the appropriate nearby station were then dispatched to deal with the potential calamity.

Kershner produced a building that served to protect Tulsans, and the story of its service was conveyed by intricate terra-cotta frieze work around an unusual octagonal floor plan.

On the façade at the main entrance are fire-breathing dragons. Above them, lightning bolts expressing speed and energy radiate from a muscular male figure, stripped to the waist, holding an alarm tape. On either side of him are helmeted firefighters whose equipment—pickaxes and hoses—can be found winding through the frieze work and above sculptures that flank nine windows at the back of the building. Emphasizing the work of firefighters, panels placed at intervals around the building depict hoses with nozzles shaped like dragon heads.

After the Tulsa Fire Alarm Building was no longer in use in 1984, it fell into disrepair and was damaged in the 1984 flood. Vandals destroyed part of the façade and stole the PWA-style light fixtures at the entry.

Marty Newman, chairman of the Tulsa Preservation Commission, purchased the building in 2000 and sold it to the American Lung Association for its new headquarters. The association conducted a $5 million fundraising campaign for a complete renovation.

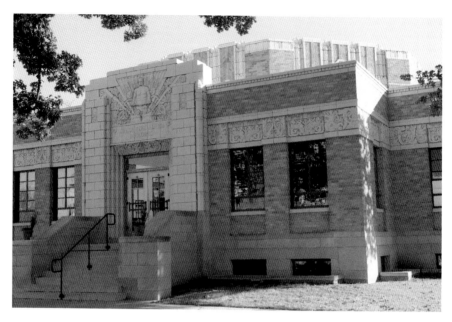

Tulsa Fire Alarm Building.

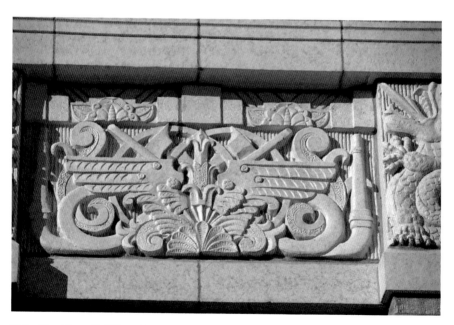

Tulsa Fire Alarm Building frieze.

In a 2001 interview, Herb Fritz, AIA, also a member of the Tulsa Preservation Commission and principal of Fritz Baily Inc., referred to the Tulsa Fire Alarm Building as a treasure. "It will be great for that wonderful building to be restored and used again," he said. "We as a city are beginning to understand how important history is, and buildings are part of that history."[40]

Firefighters initiated a fundraising campaign in 2015 to purchase the Tulsa Fire Alarm Building, which the Carol Tandy Foundation then bought and donated to Tulsa Firefighters Museum Inc. On March 17, 2015, during a KOTV News on 6 interview, Carol Tandy explained, "It is meant to be their building. They should have it. Tulsa needs a place to honor the men and women who serve our city."

WILL ROGERS HIGH SCHOOL

Since its completion in 1939, Will Rogers High School has frequently been called by architecture critics and scholars "one of the best examples of Art Deco high school architecture in the United States."[41]

In 1942, both *Time* and *Life* magazines recognized Will Rogers, which is in the Tulsa Public Schools system and was built as a PWA project. The April 3, 1942 edition of *Life*—with photographs by the famed Alfred Eisenstaedt—featured a six-page spread on high school education in Tulsa. The story focused on three schools: Rogers, Central and Daniel Webster High School, another PWA creation.

Will Rogers High School held its first classes in 1939 and was dedicated on November 3 to correspond closely with the sixtieth birthday of famed Oklahoman and world-famous entertainer Will Rogers, who had died four years earlier in an airplane crash.

Architect Joseph Koberling explained, "We felt that it should be a worthy tribute in memorial to a man everyone loved so well. It seemed to us, that the building should be monumental in character."[42]

In designing the building, Koberling collaborated with another noteworthy Tulsa architect, Leon B. Senter. Others on the design team included talented designers and craftsmen from Chicago such as John Sand and Karl Kolstad. Arthur M. Atkinson, another popular Art Deco architect, supervised the project.

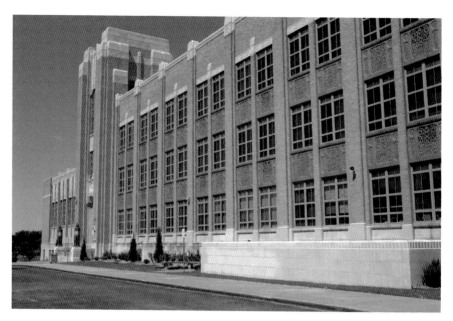

Will Rogers High School.

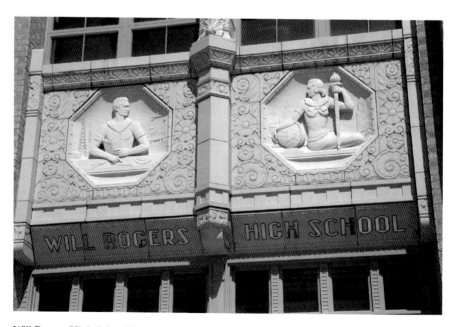

Will Rogers High School front entry detail.

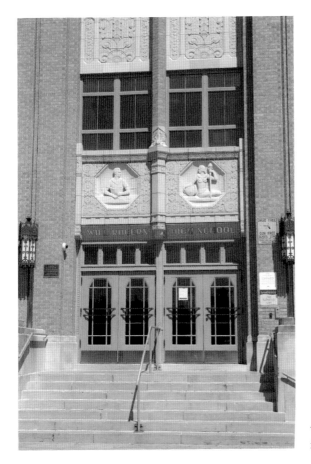

Will Rogers High School front entry.

Unlike most PWA-style buildings, this massive structure is striking in its detail, including the façade, two large wings topped by towers, the immaculate interior of terrazzo hallways, gold-leaf doorways and brass grills festooned in fans and floral trim. The breathtaking auditorium is a Deco showcase from top to bottom, including the light fixtures and chairs.

"The elaborate Art Deco building was designed to instill pride, not only in the school itself by its design, function and beauty, but by its reference to an important native son, Will Rogers," according to a National Register description of the structure.

In continuous use since its opening, Will Rogers High School has maintained its architectural integrity and extraordinarily good condition in spite of an addition in 1949 to the east classroom wing and additions in 1964 to the west classroom wing. In 2007, Rogers became one of only a few schools in the nation selected for the National Register of Historic Places.

STREAMLINE

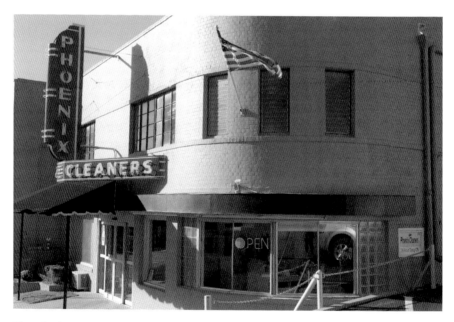

Phoenix cleaners.

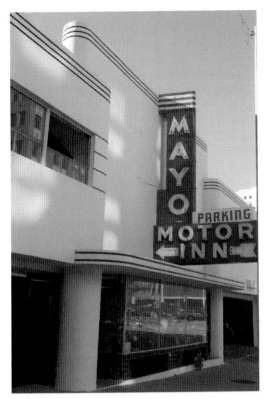

Left: Mayo Motor Inn.

Below: Wenthoff residence.

John B. McGay Residence

John B. McGay hired architect Joseph Koberling to design a new residence for the McGay family in Tulsa. The Streamline Art Deco structure with Zigzag elements was constructed in 1936 after several years of work by Koberling and McGay, who insisted on lending a helping hand. The house at 1551 South Yorktown Place attracted attention with corner windows, an unusual feature at the time, and a garage placed at the front of the home. Serendipity no doubt played a role in the location of the garage. McGay, a spirited business leader, was active in the production, use and service of automobiles.

After Carl Magee, an Oklahoma City newspaper publisher, invented the parking meter in the early 1930s, the meters were originally manufactured at the MacNik Company to meet the quickly growing demand for regulated downtown parking. The company, based in Tulsa, had been founded by John McGay and partner George Nicholson to produce timers for use in exploding nitroglycerin in oil wells.

McGay was an inventor in his own right. He gave us the gas calculator used by filling stations, and during World War II, he invented the tubeless tire as a means of conserving rubber.

Tulsa Monument Company

The Art Deco Streamline-style Tulsa Monument Company building was constructed in 1937. The long one-story building is white stucco with a symmetrical façade. The tall main entrance features a clock on each of three sides.

The business, now Benchmark Monument Company, dates back to a company operated by L.G. West in 1896. Prior to going into the monument business, West had rented space to a marble-company salesman who left on a collecting trip from which he never returned. When considering what to do with the gravestone samples the salesman had left behind, West made a wise career move—selling the materials rather than simply disposing of them.

When owners of the company decided to move in 1936 from Brady Street in downtown Tulsa to Eleventh Street in the suburbs, architect Harry Hamilton Mahler told the owners that a good way to market their business

would be for the building to resemble a tombstone, the product they would be selling. Lee Anne Zeigler, former executive director of the Tulsa Foundation for Architecture, quips that the building is monumental in its design.

The handsome Art Deco structure has stood the test of time because of owners such as Mike Rives. According to his son, Mike Rives Jr., Rives loved the building when he bought the business in 1983.

"I've seen monument shops all over the country," said Rives, echoing his father's interest. "There are some monument companies I've seen that are nice buildings, and new buildings, but there are none that have the style that this one has."[43]

Holland Hall/Boulder on the Park

The first classes taught at Holland Hall School were conducted near the Creek Council Oak in the home of John Veasey, who founded the school in 1922. A year later, thanks to the financial support of several business leaders, including Waite Phillips and Bill Skelly, a new school with nine classrooms, a shop, auditorium, offices and a chemistry laboratory was constructed south of downtown on Boulder Avenue.

The city was growing. By 1930, enrollment at Holland Hall had increased to sixty students and eight teachers, causing the school to relocate again. Aero Exploration Company purchased the property in 1938. After the Art Deco Streamline building was remodeled in the late 1940s, KTUL Radio Station bought it and coined the term "Boulder on the Park" during twelve years of broadcasting.

Newspaper Printing Corporation

Built in 1947 in the heart of downtown Tulsa, the Newspaper Printing Corporation building is an example of the Streamline Art Deco style popular at the time. Although not one of the primary Deco structures in the area, the building and the company bring to mind the colorful history of local newspapers.

Tulsa was a rough-and-tumble Creek Nation village and cattle shipping point in 1884 when its first newspaper—a weekly called the *Indian Chief*—

was founded in a tent by Ott Boone. Eventually, new owners changed the name to the *Indian Republican*. Just two months before oil was discovered in the Glenn Pool south of Tulsa in 1905, the paper became the *Tulsa Daily World* (the word *Daily* was dropped from the name in 1977) and was sold for a nickel a copy.

Native Missourian Eugene Lorton was hired as editor of the *Tulsa Daily World* in 1911. In 1917, he became sole owner. He ran the newspaper for thirty-eight years, opposing Prohibition, fighting the Ku Klux Klan, backing liberal and conservative causes and campaigning for public-works projects. A friend described Lorton as "a man covered with scars…but none on his back." The Lorton family owned the newspaper for ninety-six years before selling it to Berkshire Hathaway's BH Media Group in early 2013.

In 1919, the *Tulsa Democrat*, originally called the *Tulsa New Era*, was purchased by Richard Lloyd Jones, cousin of famed architect Frank Lloyd Wright, who designed the Jones family home, Westhope, an Art Deco masterpiece in Tulsa.

Jones changed the name of the newspaper to the *Tulsa Tribune*. His son Jenkin Lloyd Jones Sr. served as the *Tribune*'s editor from 1941 to 1988 and as its publisher until 1991, the year before the *Tribune* folded. His weekly column was syndicated in more than one hundred newspapers.

The *Oklahoma Eagle* succeeded the *Tulsa Star* and the *Oklahoma Sun*, two of the city's early African American newspapers. The weekly newspaper covering news in north Tulsa has been owned and operated by members of the Edward Lawrence Goodwin family since 1936. With an emphasis on the African American community, the *Oklahoma Eagle* continues to live up to the words on its masthead: "We make America better when we aid our people."

• PART III •
LOST AND FOUND

According to Rex Ball, architect and preservationist, all the architecture in Tulsa, taken as a whole, is as much a resource to the economy as anything else in the state.

FROM BUST TO BOOM

From the mid-1920s into the 1950s, scores of buildings representing the distinct styles of Art Deco architecture appeared in Tulsa. There was no holding back those competitive risk takers trying to outdo one another and the visionaries they engaged to design and build their luxurious homes and elaborate corporate palaces.

Even after the crash of 1929 and the subsequent economic downturn that was so devastating it became known as the Great Depression, the upper echelon of Tulsa's gentry had ample reserves and continued to live and work in style. As one observer of the day put it, "Tulsans erected skyscrapers not so much because ground space was at a premium, but because they like to see them rise."[44]

Throughout the Depression, World War II and well into the 1950s, Tulsans witnessed the transition of Art Deco architecture from the colorful and ornate Zigzag to PWA (for the New Deal's Public Works Administration) to the Streamline and Deco Moderne. Yet in postwar Tulsa, as was the case across the nation, change was in the air.

The mood in 1945 was optimistic. Wartime rationing ended, and automobile production resumed. There was vigorous economic growth. As the troops came home from Europe and the Pacific, the birthrate exploded. The GI Bill enabled large numbers of veterans to finish high school and attend college. This resulted in higher incomes for average Americans. New housing was in great demand, and the federal government's Veterans Administration loans resulted in a building boom in surrounding bedroom

communities and new suburban residential developments south and east of downtown Tulsa.

Tulsa evolved into a strikingly handsome city surrounded by a burgeoning metropolitan area and imbued with plenty of civic pride and corporate muscle. As a result, Tulsans reveled in the rich heritage but also desired to progress. By the late 1940s, Art Deco architecture had declined in popularity in Tulsa. Not only had times changed, but tastes as well. A "Downtown Tulsa Survey" conducted in 2009 summed it up:

> *In the post–World War II period, buildings, especially commercial buildings, got bigger and sleeker. All vestiges of architectural ornament and references to historic styles were removed. Skins of glass and metal replaced traditional veneers of brick and stone. Windows became expansive ribbons of glass rather then punched openings. Sixty-eight buildings of this genre rose in downtown Tulsa during the post-war boom. Commercial business and government institutions alike embraced forward-looking Modern Movement architecture to represent their own visions of the future.*[45]

The die was cast for the future of any new Art Deco commercial buildings or residences in Tulsa. In 1960, the federal government launched a new policy of Urban Renewal, an ambitious program that ultimately yielded some remarkable results.

"Tulsa leaders used this federal program, generally with success, to change the built environment of downtown," according to the city's 2009 Historic Resources Survey. "While residents today express remorse at the demolition of both residential and commercial buildings that resulted from Urban Renewal, a significant number of buildings erected through this period deserve recognition for their architecture. These buildings also testify to the efforts of local city leaders and business owners who believed a new city image would keep the business core viable."[46]

Not everyone in the preservation community agreed with such a glowing assessment. In many circles in Tulsa and elsewhere, Urban Renewal remains what American urban historian Jon C. Teaford called "the most universally vilified program in planning history, remembered primarily for its destruction of established central, urban neighborhoods along with the construction of isolated, peripheral housing projects."[47]

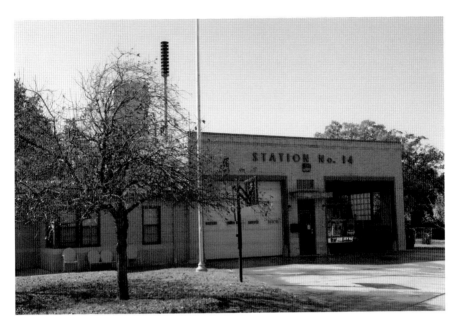

Fire Station No. 14.

In July 1959, the Tulsa Urban Renewal Authority (TURA) was formed, making Tulsa the first large city in Oklahoma to buy into the federally sponsored program. Through frequent use of eminent domain, TURA acquired a multitude of buildings and sites that the city pronounced as "blighted." Before long, the downtown that once had reverberated to the sound of builders erecting Art Deco palaces resonated from demolition blasts and the thuds of wrecking balls creating great piles of rubble. In truth, some of the buildings that were destroyed had become eyesores, but others were removed solely to make room for new structures, a plethora of surface parking lots that left gaping holes in the city's streetscape and new highways that tore through long-established neighborhoods. All of it was carried out in the name of progress.

Almost from the start of the Urban Renewal program in Tulsa, the downside of some projects became evident. An economic study commissioned by the city in 1963 pointed out that the growing number of downtown parking lots was unusually high.

"Many of those parking lots have developed not because someone simply wanted to have a parking lot, but because the building which once occupied the site no longer could economically justify its existence," the report said.

"The appearance of a large number of parking lots usually is a signal of economic difficulties, and often foreshadows change in land use."[48]

The glut of surface parking lots and the need for additional multistoried public and private parking garages and on-street parking continued for decades.

"Tulsa, we have a problem," was how Bill Leighty, executive director of Smart Growth Tulsa, a nonprofit organization that advocates an improved public parking policy, described the city's downtown parking dilemma in 2013.

> *Too many of our historic and iconic downtown buildings have fallen prey to the wrecking ball. Too many ugly surface parking lots have taken their place. This untenable situation began in the 1960s and has been escalating since. It has led Tulsa to a most dubious distinction. We were recently anointed the national champion of Parking Madness, and awarded the first "Golden Crater" award by Streetsblog, the national internet news service devoted to sustainable transportation and livable communities which dubbed us as the worst parking crater in America.*[49]

Although positive steps have been taken to address the city's surplus of parking lots, other negative aspects of Urban Renewal in Tulsa were not addressed. One thing both sides of the debate can agree on is that for better or worse, Urban Renewal unquestionably played a significant role in the city's architectural history, and the legacy of the controversial program of infill and redevelopment is still apparent today. Much of what was lost can never be recovered.

All of the magnificent and ornate downtown movie palaces—the Ritz, Rialto, Orpheum and Majestic—along with popular neighborhood Art Deco theaters such as the Delman, Brook and Will Rogers are long gone, replaced by businesses or generic box and megaplex cinemas in cookie-cutter malls and strip centers. Gone too from the once vibrant downtown shopping district are most of the early hotels, such as the once bustling Bliss Hotel, razed in 1973, and the grand department stores offering upscale merchandise. Some closed and went out of business, and a few moved to shopping centers outside of downtown, where they eventually withered and died.

Urban Renewal also brought about urban sprawl as retailers and their customers fled downtown and relocated in the suburbs and predictable residential developments springing up in far south Tulsa. During the 1970s,

city planners and others tried to curtail the exodus from the core of the city by developing the pedestrian-friendly Main Mall, paid for with financing through Urban Renewal funds. Proponents believed that the conversion of Main Street into a seven-block pedestrian park was the best way to retain and attract retailers.

Like the other U.S. cities that experimented with main malls, Tulsa found that it was a failure. Instead of becoming a lively artery of activity and commerce, the mall was busiest for occasional street festivals or when office workers ate their sack lunches there, weather permitting. At night, most people left downtown and headed to their homes outside the central core. When the sun went down, the mall was an attractive venue for homeless people or, as one pundit said, folks with no better place to be.

The main-mall concept lost credibility when a nationwide study revealed that pedestrian malls in the United States have an 89 percent failure rate, and most have been removed or repurposed.

Thankfully, in the early 2000s, Tulsa reopened downtown Main Street to vehicular traffic. Almost immediately, there were significant improvements in retail sales, more investments and an increase in property values.

Proponents of Urban Renewal believed the program was more successful in Tulsa than in other cities, but even they had to admit that in the long run, it failed to meet expectations when it came to reviving the city core. "The Civic Center Complex, the Main Mall and Urban Renewal were linked attempts to renew downtown as a retail, entertainment and business center and were only partially successful," according to one of the resource surveys of the city.[50]

"The character of the city continued to evolve, as buildings with large footprints replaced the dense conglomeration of smaller buildings built before World War II," according to a Tulsa Preservation Commission report. "With the loss of retail activity and the addition of new modern office towers, by 1970, downtown Tulsa more closely resembled a suburban business park than the vibrant multi-use downtown it had been earlier in the century."[51]

A badly needed wake-up call stirred city leaders and concerned citizens to take stock of their city and its future. Tulsa was accustomed to the cyclical booms and busts of the oil industry, but in the early 1980s, the price of a barrel of crude oil was about thirty dollars and rising. Oklahoma's oil was still the lifeblood of Tulsa.

Then came the one-two punch of overproduction of oil by the OPEC cartel and a crippling national recession. Between 1982 and 1987, oil prices

declined sharply, which led to the oil industry eliminating jobs for many years to come. The industry turned to the oil reserves in the Gulf of Mexico, and many oil operators left Oklahoma and went due south to Texas. Soon the title "Oil Capital of the World" that Tulsa had proudly held for decades was relinquished to Houston. A four-word headline in the May 11, 1986 *New York Times* stated the cold, hard truth: "Desperation Descends on Oklahoma."

Like most Oklahomans, the citizens of Tulsa proved to be resilient. When the oil industry declined and gas prices went into a freefall, many oil firms pulled out of town. Instead of wringing their hands or turning tail, Tulsans kept moving forward. Together, civic and business leaders worked hard to further diversify the city's economy by attracting more aviation, telecommunications, health care and technology businesses to Tulsa. The citizenry did not flinch but joined in the effort to bring their city back and revitalize one of Tulsa's most important resources—the culturally and historically valuable downtown.

Voters overwhelmingly approved critical funding initiatives to cover a wide range of capital improvements and economic-development projects. Every effort was made to stimulate new jobs and opportunities, create educational programs and encourage private investment in Tulsa's downtown. Foundations and the private sector stepped up and offered millions in matching funds.

By the 1990s, the city realized that important aspects of the community were not being properly used, such as the Arkansas River flowing near downtown, the historic and revived Route 66 corridor passing through the city and, of course, the incredible collection of eye-catching Art Deco buildings that remained. Investors began buying up any available property in downtown Tulsa and repurposing historic buildings for business and residential use.

In 1995, members of the Eastern Oklahoma Chapter of the American Institute of Architects (AIA) founded the nonprofit Tulsa Foundation for Architecture (TFA). The concise mission statement made its intentions clear: "Tulsa Foundation for Architecture champions the art of good design and celebrates Oklahoma's architectural heritage."

TFA leadership included local architects Herb Fritz, Ted Reeds, Lanny McIntosh and Leisa Marshall, along with engineer Tom Wallace, realtor and preservationist Marty Newman and other noted professionals and community leaders and activists. Elaine Bergman, at the time the director of the AIA Eastern Oklahoma Chapter, brought the group together and became TFA's first executive director. In later years, when Bergman relocated

to New Mexico, TFA was guided by two other capable and talented executive directors, Lee Anne Zeigler and then Amanda DeCort.

From the start, TFA became widely known as "Tulsa's Architectural Voice." That voice was loud and clear, and it came along at precisely the right time. The group did indeed champion good design, and that definitely included Art Deco architecture.

In 2001, the Art Deco architectural treasures of Tulsa gained worldwide attention when the TFA joined with several other sponsors, including Tulsa Historical Society and the Tulsa Preservation Commission, to host the Sixth World Congress on Art Deco. The four-day event attracted attendees from England, Ireland, New Zealand, South Africa, Australia and across the United States.[52]

The congress focused primarily on the work of celebrated architects Bruce Goff, Leon B. Senter, Joseph Koberling and Frank Lloyd Wright. It provided a scholarly forum for the discussion of raising the level of public awareness of Art Deco, promoting Deco as a worldwide design movement, the preservation and conservation of endangered sites and methods of using Art Deco as an opportunity for economic development. The international event also put Tulsa at the epicenter of the Art Deco preservation movement.

"All the architecture here, taken as a whole is as much a resource to the economy as anything else in the state," said architect and preservationist Rex Ball, chair of the Sixth Congress.[53] Many others agreed, including Mitzi Mogul, chair of the International Council of Art Deco Societies. Mogul departed Tulsa singing the praises of the city's broad inventory of Art Deco structures and those responsible for building them.

"The incredible prosperity of the '20s contributed to a building boom and that was certainly true here in Tulsa," Mogul said. "There was a sense of philanthropy that went beyond just giving money. There was a sense of responsibility to the community. They felt they had to give back and what they had to give back was public architecture. Public art—and that's really what architecture is."[54]

Just seven years after the World Congress on Art Deco came to Tulsa and ensured the city's place among the great Art Deco cities of the world, the spotlight again shone on Tulsa's inventory of vintage buildings. In 2008, the downtown hotels overflowed with more than twenty-five hundred preservationists, scholars, architects and urban historians as Tulsa hosted the National Trust for Historic Preservation Conference. The title of the conference was perfect: "Preservation in Progress." Growing

numbers of Tulsans were committed to positive change and understood that preservation was the key.

"The architectural legacy of this city is absolutely astounding," said James Schwartz, editor-in-chief of *Preservation*, the prestigious magazine of the National Trust. "It's thrilling for us to be able to share the Tulsa story with readers."[55] Schwartz was so thrilled that he spotlighted Tulsa's Art Deco treasures on the magazine cover. Wayne Curtis wrote in the cover story:

> *It may come as a surprise to learn that Tulsa is one of the nation's premier centers of art deco architecture, putting it in the classy company of Miami Beach, New York, and Los Angeles. The style was hugely popular here from the outset and remained so through several evolutions—as the geometrically ornamented structures of the 1920s gave way to simpler and more heroic public architecture of the Great Depression and then to the sleek streamline moderne of the later 1930s. Over the course of a four-day visit I walked through downtown and drove along outlying streets, taking in the full range—from the brightly colored terra cotta panels of the 1929 Warehouse Market to the curved glass-block corners of the 1942 City Veterinary Hospital.*[56]

Tulsa had built up the momentum for a true revival of Art Deco architecture. It became apparent that it would last. Attitudes had changed, and what was thought to have been lost had been found.

Diligent preservationist Marty Newman said it best: "Nobody in Tulsa would take down an art deco building without thinking about it good and hard. There would be repercussions."[57]

HERB FRITZ: DECO WARRIOR

"You know it when you see it."

That was how Herb Fritz, architect and historic preservationist, once defined Art Deco.[58] He knew there was controversy surrounding the style, but that did not stop him from championing irreplaceable architectural nuggets such as the Tulsa Fire Alarm Building and the Bruce Goff–designed Riverside Studio (Spotlight Theatre).

Herb Fritz was born in the picturesque German village of Jugenheim in 1950. The Fritzes grew hops, the seasoning for beer. Herb played in the

fields as well as in the nearby forests of Odenwald. When he was six years old, the Fritzes moved to New York, where they operated a busy knitting mill.

Only German was spoken at home, and although Fritz quickly learned English, his parents insisted that he continue to attend a German school. He finally convinced them to let him quit German school if he could get into Brooklyn Technical High School. There he studied engineering, math and science and made friends with five boys, all of whom fostered an interest in architecture.

In a whimsical move, the boys decided to leave the East Coast after graduating from high school. They applied to Oklahoma State University (OSU) and were accepted. Knowing little more about Oklahoma than the name of the state, the teenagers boarded a plane to go west and looked for the Pacific Ocean when they landed. In spite of finding themselves in the middle of the country rather than on the West Coast and discovering that OSU students called themselves cowboys, what most impressed the New Yorkers was the friendliness of their fellow students from the West.

Herb Fritz at the Tulsa Fire Alarm Building. *Courtesy Tulsa Foundation for Architecture.*

Fritz earned degrees in architecture and sociology at OSU and moved to Chicago, where he worked with the prestigious firm Skidmore, Owings & Merrill. But he decided Oklahoma was where he wanted to establish his career. He met and married Debbi Bonifazi, and together they raised two sons, Michael and David.

In 1977, Fritz returned to work for the architectural firm Murray Jones Murray in Tulsa. Seven years later, he and Ted Baily cofounded Fritz Baily. In 1999, the firm moved into the Knights of Columbus Building on Baltimore Avenue.

It should come as no surprise that Fritz went to work every day in a historic building. In addition to his work on medical facilities, museums (the renovation of the Travis Mansion, now home of the Tulsa Historical Society), office buildings (including a new facility for Family & Children's

Services), parks and municipal projects such as the renovation of the Tulsa International Airport passenger terminal, he also was an important advocate of protecting and preserving Tulsa's architectural treasures. A longtime member of the Tulsa Preservation Commission, Fritz served on the board of Preservation Oklahoma, and in 1995, he cofounded the Tulsa Foundation for Architecture.

Herb Fritz passed away in 2014, but Tulsans are reaping the benefits of the legacy he left behind. Downtown revitalization and Art Deco preservation were causes he supported passionately. Friends and colleagues noted the love Fritz had not only for the community's future but also for its history.

Lee Anne Zeigler, former executive director of Tulsa Foundation for Architecture, said the downtown environment as a whole, not just the buildings, profited from Fritz's work. He not only wanted to protect and preserve the architectural treasures, he wanted them to be there for future generations to experience and enjoy.

Amanda DeCort, current executive director of the foundation, speaks fondly of Fritz as her mentor, friend and inspiration. When referring to his preservation projects, she points out his award-winning face-lift of Will Rogers High School—"architecturally the crown jewel of the city's public schools district"—and the renovation of Tulsa's historic Fire Alarm Building, which she says "would probably be a pile of rubble now. But like he did with so many places, Herb really saw the potential in it and was able to convince others what a great property it could be."[59]

• PART IV •
ECHOES OF DECO

History does repeat itself,
and sometimes it turns out to be for the better.

THE LEGACY LIVES

Historic preservationist Marty Newman's prediction that no more Art Deco buildings would be demolished in Tulsa was spot-on. Art Deco architecture has become one of the major influences sparking downtown Tulsa's revival in the 2000s. Many of the regrettable missteps of Urban Renewal, including the demolition of far too many historic edifices, has been addressed. Art Deco once again has taken its place as a major force shaping the city's future.

Art Deco became a key element in a downtown resurgence fueled by public support and the generosity of Tulsa's philanthropic community, driven largely by the arts and culture pumping new life into the city.

Echoes of Deco continue to show up everywhere in the city. The Metropolitan Tulsa Transit Authority (MTTA) building, built in 1999 as a major transfer site, is a good example of retro Deco. The same is true of the retro Streamline-design headquarters building designed in 1999 for Myers-Duren Harley-Davidson, which had been founded in 1912 when Tulsa was earning its sobriquet of Oil Capital of the World.

Much of the significant revival of the city occurred after the 2008 opening of the nearly twenty-thousand-seat BOK Center, a multipurpose arena designed by César Pelli for sports and major entertainment events in the heart of downtown. That was followed two years later by new Art Deco–style ONEOK Field for the Tulsa Drillers baseball team, adjacent to downtown in the Greenwood Historical District. The neighborhood had risen out of the ashes of the infamous 1921 race riot to become an expanded

Reba McClanahan, owner Myers-Duren Harley-Davidson.

mixed-use area and the site of John Hope Franklin Reconciliation Park and Greenwood Cultural Center.

Other areas of Tula established their own distinct districts or in some cases enhanced and nurtured existing districts in midtown, including the Pearl District, Brookside District, Cherry Street District and Kendall-Whittier District. The Brady Arts District, Blue Dome District and East Village District in downtown Tulsa became major draws for locals and visitors by developing an impressive array of eateries, clubs, retail shops, galleries, museums and cultural attractions.

In 2010, the heart and soul of downtown got its own special district when the nonprofit Downtown Deco District Association was formed by the Tulsa Regional Chamber of Commerce and downtown business owners representing hotels, restaurants, banks, law firms and dedicated Deco enthusiasts. They are led by William Franklin, a bona fide Deco champion and the owner and operator of Decopolis, a stylish boutique offering retro-style gifts and tempting purchases for Art Deco shoppers. All the association members have a mutual goal: to celebrate Tulsa's historic Deco District while promoting downtown living, shopping, working and entertainment.

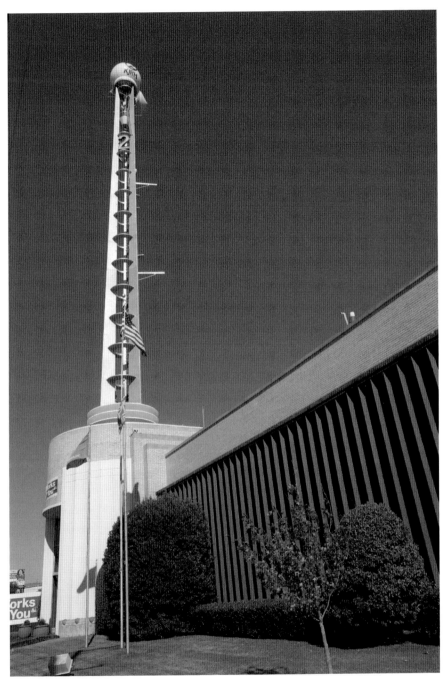

KJRH-TV tower.

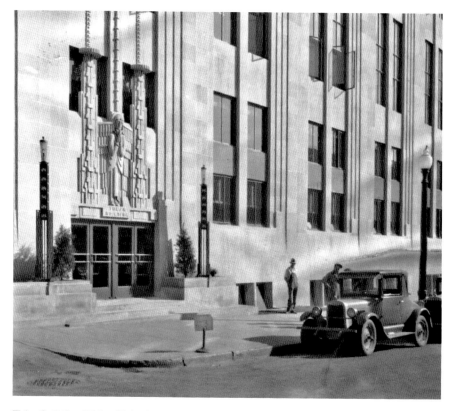

Tulsa Building/Tulsa Club. *Courtesy Tulsa Historical Society.*

Investment in historic buildings continues, as does the transformation of vintage commercial structures into comfortable and convenient living quarters for the many people moving back to the core of the city.

A good example in the Deco District is the complete resurrection of the eleven-story Tulsa Club Building, a Zigzag masterpiece designed by Bruce Goff and built in 1927 as a joint venture between the Tulsa Club and the Tulsa Chamber of Commerce. Vacant since 1994, the building—at one time the destination for oil barons—endured several owners and incarnations as well as vandalism and, in 2010, a fire. Thankfully, the bones of the building remained stout.

Targeted as a public nuisance and cited for a score of code violations, the building was sold at public auction in 2013. It was purchased by the Ross Group, a major construction firm headquartered in downtown Tulsa, led by MIT-trained Warren Ross, one of the city's valuable visionaries. Ross immediately laid out plans for a $24 million conversion of the Tulsa Club

Tulsa Art Deco Museum display.

structure into a hotel and retail space, a sterling example of what is taking place in the Deco District.

The district encompasses a substantial area, with much to see for all those who take a guided or self-guided tour. The must-stop attraction for everyone is Tulsa's Art Deco Museum, established in 2009 and opened in 2012 in the magnificent marble lobby of the historic Philcade, one of the city's most iconic Art Deco structures. Art Deco objects—actual pieces of buildings that have vanished from the Tulsa skyline—fill the large glass window enclosures lining the lobby walls. There is no admission fee, and all proceeds from sales in the museum shop support operational costs.

The Deco Museum is one of the domains of Debby Kelsey, a tireless volunteer and passionate Deco collector and advocate who taught third grade for twenty-four years in Tulsa Public Schools. Her passion for all things Art Deco includes architecture and objects ranging from clothing and furnishings to works of art and utilitarian artifacts. As a result, Kelsey earned a special name. In Art Deco circles, she is widely known as "Deco Debby," a moniker she proudly accepts.

Tulsa Art Deco Museum, "Deco Debby" collection items.

"Deco Debby" did not become a Deco devotee until 1982, and she began to collect Art Deco about ten years later. "It has become quite an inspiration and an important part of my life," she said. "I knew in my heart that this is what I wanted to do, and I started to become more knowledgeable about Deco."[60] She continues to haunt the popular flea market held weekly at the Tulsa State Fairgrounds. "I go there, and when I see something I want, it is like *bingo*! I buy it."[61]

During one of her frequent shopping expeditions at the flea market, Kelsey happened upon William Franklin, who asked, "Are you 'Deco Debby?'" Surprised that Franklin was aware of her penchant for Deco design, she invited him to her home to see her extensive collection of objects.

Franklin was duly impressed and soon recruited Kelsey to become a team player in Tulsa's burgeoning Art Deco revival movement. Many of her prized collectibles—including figural lamps, incense burners, statuary, bookends, fishbowl stands and holders, cigarette lighters and holders and even a monkey-skin muff from the 1920s—are on display at the museum in the Philcade lobby.

"I'm very grateful to William," said Kelsey. "He has given me a way to share my collection with the public."[62]

It appears that like the revitalization of historic Route 66 and the thoughtful development along the Arkansas River, Tulsa's Deco has not only made a comeback but is definitely here to stay. The city's renewed interest in Deco architecture prompted Wolf von Eckardt, the renowned design and architectural critic, to describe Tulsa as having "the finest Art Deco buildings in the country"[63]—high praise that might be disputed by a few other Deco havens. But there is no question that another Eckardt observation about Tulsa can never be questioned: "People here are discovering their Art Deco buildings and are treasuring them. That is very impressive. You can sense the pride, the love in the restorations."[64]

It is a fitting tribute, but the words of Barbara Baer Capitman—the undisputed "First Lady of Art Deco"—serve as the most appropriate benediction of all: "Tulsa truly is a marvelous and unusual Art Deco city. I have seen some of the best—absolutely best—examples of Deco buildings anywhere within a few blocks of downtown Tulsa. It's all over the city!"[65]

History does repeat itself, and sometimes it turns out to be for the better.

William Franklin

When William Franklin opened his downtown gift shop, Decopolis, in 2011, he knew he was taking a chance. His customers would ask, "Where are all the people?" Without missing a beat, Franklin would point out the growing resurgence of interest in Tulsa's central business district.

"Sometimes it seemed like a long haul," he says, "but I believed there was a benefit to locating here. Once people began gravitating to downtown for recreation, as well as for work, we would be an important player."

During the 1950s, downtown retailers and dining establishments turned their attention away from the central business district. Shopping malls began to appear outside downtown to serve the needs of families building homes in new subdivisions. The center from which the city had first grown soon became a hive of offices from which employees took flight at the end of the eight-hour workday. It was not until the dawn of the new century that downtown Tulsa came back to life as a vibrant metropolitan center of entertainment, sports, retail and dining.

William Franklin was in the advance guard taking a stand to bring Tulsans back downtown. In keeping with the style of many early midtown buildings, his gift shop on Boston Avenue reflects the Art Deco architecture surrounding him. Books, clothing, kitchenware, men's and women's specialty items, jewelry and pieces of art on sale all capture the spirit of Art Deco past and present. Toys popular fifty years ago captivate adults and children alike. Decopolis offers the essence of memories blended with curiosity and style.

An entrepreneur with a deep appreciation for the civic and architectural contributions of the past, Franklin is an artist in his own right. Look around his shop and in the Art Deco Museum displays set in the lobby windows in the Philcade and you will see the end results of his talent. He brings a canvas to life in black and white or in color and has for more than twenty-five years specialized in residential and business trompe-l'oeil murals around

the country and in Europe. In 2009, he was the Tulsa International Mayfest poster artist, and he has added new pieces of artwork from each year's poster to the Mayfest "Kite Mural" on the Hyatt building facing Main Street. When Franklin and his team completed a project in Florida, it was brought to the attention of Disney CEO Bob Iger, resulting in an invitation for the team to work as Disney Imagineers.

William Franklin's obsession with Art Deco dates back to the days of the early oil boom when William Skelly, president of the Tulsa Chamber of Commerce, suggested the city host a trade fair where everyone—industry workers and the general public—could learn about oil production. In addition to a display of all the latest technology, equipment and services were offered for sale. It was an idea that met with resounding success. The International Petroleum Exposition (IPE) was held annually on the circus grounds downtown from 1924 to 1927, after which it was moved to the fairgrounds for the next forty-five years.

In 1941, Clarence Allen, a well-known Tulsa artist, was commissioned to design a monumental forty-foot statue to stand in front of the IPE building at the entrance to the fair. His idea was to create a personification of oil, a goddess holding an eternal flame over her head. William Franklin's grandmother Marjorie Morrow was hired to serve as a model for the artist. He selected the nineteen-year-old Central High graduate because she had the same measurements as Betty Grable, the most popular pin-up girl at the time.

Marjorie, already holding down two jobs, applied for the role of model as a means of earning extra money to pay for art lessons. She was taken aback when told she would be posing nude, but knowing the artist's good reputation, she did not hesitate to accept the job. For good measure, Allen's landlady perched herself right outside the studio door to make certain no monkey business took place.

Allen completed a three-foot statuette to present to the IPE committee for approval and use later as a model when creating the forty-foot statue. However, World War II erupted, putting the project on indefinite hold. Marjorie Morrow went to Washington and worked for the FBI until returning to Tulsa, where she met and married Bob Anderson, a Spartan Aeronautics pilot. Many years later, Clarence Allen gave the goddess statuette to Marjorie.

In 1953, a Texas oil-field supply company created the *Golden Driller*, a huge roustabout that was set up at the entrance to the Tulsa State Fairgrounds. The statue was temporary but very popular. A second temporary version appeared in 1959 and again proved popular enough that a permanent *Golden*

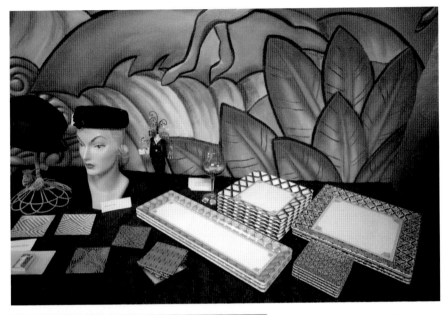

Above: Tulsa Art Deco Museum merchandise display.

Left: William Franklin, artist.

Driller was created in 1966. Mustard-colored plaster and concrete rather than golden, the giant driller with his hand perched atop a real oil derrick containing two and a half miles of rods and mesh is the tallest free-standing statue in the country. The *Golden Driller* was adopted as the state monument by the 1979 Oklahoma legislature and twenty-five years later was named the grand prize by Kimberly-Clark as one of the top ten "quirkiest destinations" in the United States. The giant statue continues to attract attention around the country and abroad. In June 2017, a thrill ride based on the *Golden Driller* was opened in Fraispertuis City, a Wild West theme park located in the Alsace-Lorraine region of eastern France.

Marjorie Morrow Anderson. *Courtesy William Franklin.*

The Goddess of Oil may have been set aside in the 1940s, but she was not forgotten. She recently appeared on the label of a local Art Deco wine series.

Marjorie Morrow Anderson gave the statuette created by Clarence Allen to her grandson William Franklin. One of Tulsa's true Art Deco devotees, Franklin continues to plan a debut for her, perhaps when he has raised enough money to establish a free-standing Art Deco museum in what was once known as Terra Cotta City. After all, oil was the goddess to whom the early oil barons paid homage while investing their wealth in Art Deco skyscrapers to house downtown Tulsa businesses.

Appendix
TULSA ART DECO CHART

The chart that follows on the next pages is a listing of the prominent Art Deco structures built in Tulsa. Unfortunately, more than a few are no longer standing.

Appendix

Subject	Date	Style	Architect	Status	Address
Adah Robinson Residence	1927–29	Zigzag	Bruce Goff; Joseph R. Koberling added kitchen		1119 S. Owasso Ave.
Animal Detention Center/Tulsa SPCA	1931	PWA			2910 Mohawk Blvd.
Arnold Ungerman Residence	Remodeled 1941	Streamline	Leo Clark		1718 E. 37th St.
Baehler Brothers Service Station	1950	Streamline		Demolished 2015	3702 S. Peoria Ave.
Big Ten Ballroom/American Beauty Manufacturing, Inc.	1950	Streamline			1632 E. Apache St.
Bliss Hotel	1929	Zigzag	Leland I. Shumway	Demolished 1973	123 S. Boston Ave.
Boston Avenue Methodist Church	1929	Zigzag	Bruce Goff, architect; Adah Robinson, designer	National Register of Historic Places	1301 S. Boston Ave.
Brook Theater (800 seats)	1945	Streamline	William Henry Cameron Calderwood	Ceased movie presentation 1983; converted to restaurant	3307 S. Peoria Ave.
Burtner N. Fleeger Residence	1937	Streamline	Frederick V. Kershner		2424 E. 29th St.
Century Geophysical Corporation	1946	Streamline	Frederick V. Kershner		6650 E. Apache St.
Christ the King	1928	Zigzag	Francis Barry Byrne		1530 S. Rockford Ave.

Appendix

Subject	Date	Style	Architect	Status	Address
Cities Service Oil Company Station #8	1932	Streamline	M.R. Pettingill	National Register of Historic Places	1502 E. 11th St.
City Veterinary Clinic	1942	Streamline	Joseph R. Koberling	National Register of Historic Places	3550 S. Peoria Ave.
Cove Theater (600 seats)	1947	Deco Moderne		Demolished 1955	2321 W. 41st St.
Daniel Webster High School	1938	PWA	Arthur M. Atkinson John Duncan Forsyth Raymond Kerr William H. Wolaver		1919 W. 40th St.
Day and Nite Cleaners	1946	Streamline	William H. Wolaver		102 S. Elgin Ave.
Day Building	1926	Zigzag	Bruce Goff	Former Nelson's Buffeteria	512 S. Boston Ave.
Delman Theater (1,400 seats)	1938	Streamline	W. Scott Dunne	Demolished 1989	2335 E. 15th St.
11th Street Bridge/U.S. Highway 66	1916–17 modified 1929	Zigzag	Missouri Valley Bridge & Iron Co. Harrington, Howard & Ash	Closed to vehicles 1980. Gates locked 2008 to exclude all visitors. National Register of Historic Places	Cyrus Avery Centennial Plaza, intersection of Riverside Dr. and Southwest Blvd.
Fairgrounds Pavilion	1932	PWA	Leland I. Shumway		Tulsa State Fairgrounds 4145 E. 21st St.

Appendix

Subject	Date	Style	Architect	Status	Address
Fawcett Building (Stanolind/Amoco)	1926	Zigzag	Leon B. Senter		515 S. Boston Ave.
Fire Station #3	1909 remodeled 1948	Deco Moderne			1013 E. 3rd St.
Fire Station #7	1947	Deco Moderne	Joseph R. Koberling		601 S. Lewis Ave.
Fire Station #13	1931	Zigzag	Albert Joseph Love		3924 Charles Page Blvd.
Fire Station #14	1950	Deco Moderne	Joseph R. Koberling		3602 S. Lewis Ave.
Fire Station #15	1948	Deco Moderne	Hanton and Wilson		4162 E. Admiral Pl.
Fire Station #16	1948	Deco Moderne	John Wesley Robb		1401 N. Lewis Ave.
Fire Station #17	1953	Deco Moderne	Hanton and Wilson		1351 N. Sheridan Rd.
G.C. Pride Residence	Remodeled 1935	Streamline	Joseph R. Koberling	Demolished	2103 E. 3rd St.
Genet Building/American Airlines Building	1930	Zigzag	Noble Fleming Joseph R. Koberling	Demolished 1969	914 S. Boston Ave.
Gillette-Tyrrell/Pythian	1930	Zigzag	Edward Saunders	National Register of Historic Places	423 S. Boulder Ave.

Appendix

Subject	Date	Style	Architect	Status	Address
Guaranty Laundry/Page Van Lines	1928	Zigzag	Rush, Endacott and Rush Bruce Goff		2036 E. 11th St.
Halliburton-Abbott Clothing Company/Sears/Skaggs	1929	Zigzag	Frank C. Walter	Demolished 1980 and replaced by ONEOK Building	500 S. Boulder Ave.
Hawks Dairy	1948	PWA	Gerald W. Wolf	Adjoining retail outlet demolished	2415 E. 11th St.
Holland Hall School Building/Boulder on the Park	1923 remodeled 1947	Streamline	Atkinson & Olston (1923) Malcolm & McCune (1947)	National Register of Historic Places	1850 S. Boulder Ave.
Home Federal Savings/BOK	1956	Deco Moderne	Joseph R. Koberling Lennart Brandborg		31st St. and Harvard Ave.
Howard J. Sherman Residence	1937	Streamline			7228 S. Evanston Ave.
Jesse D. Davis Residence	1936	Streamline	Frances Davis		3231 S. Utica Ave.
John B. McGay Residence	1936	Streamline	Joseph R. Koberling		1551 S. Yorktown Pl.
John Duncan Forsyth Residence	1937	Streamline	John Duncan Forsyth Robert E. West		2827 S. Birmingham Pl.
John Leroy Shakely Residence	1937	Streamline		Demolished	7219 S. Evanston Ave.
KVOO Radio Station/KJRH Television Studio	1956	Deco Moderne	Joseph R. Koberling Lennart Brandborg		3701 S. Peoria Ave.

Appendix

Subject	Date	Style	Architect	Status	Address
KVOO Transmitter Station	1932	Streamline	John T. Blair	Demolished	15050 E. 11th St.
Lerner Shop	Remodeled c. 1931	Streamline			419 S. Main St.
Marathon Oil Company Station	1931	Streamline		Demolished	201 N. Boston Ave.
Marquette School	1932	Zigzag	F.W. Redlick		1519 S. Quincy Ave.
Mayo Motor Inn	1950	Streamline	Leon B. Senter	National Register of Historic Places	416 S. Cheyenne Ave.
Medical and Dental Arts Building	1927	Zigzag	Arthur M. Atkinson, Joseph R. Koberling	Demolished 1970	108 W. 6th St.
Merchant's Exhibit Building	1930	Zigzag	Bruce Goff	Collapsed into abandoned coal mine	Tulsa State Fairgrounds 4145 E. 21st St.
Metro Diner	1980	Deco Revival		Demolished 2006	3001 E. 11th St.
Metropolitan Tulsa Transit Authority (MTTA) terminal	1999	Revival	HTB Inc.		4th St. and Denver Ave.
Mid-Continent Oil Company Station	1931	Streamline	Donald McCormick	Demolished	2102 S. Utica Ave.
Midwest Equitable Meter	1929	Zigzag	Rush, Endacott and Rush; Bruce Goff		3130 Charles Page Blvd.

APPENDIX

Subject	Date	Style	Architect	Status	Address
Midwest Marble and Tile	1945	Streamline	Robert E. West		507 S. Quaker Ave.
Milady's Cleaners/La Maison	1930	Zigzag			1736–38 East 11th St.
Morrow Geophysical Building/American Red Cross Building	1948	Streamline		Art Deco elements removed during remodeling	3345 S. Harvard Ave.
Myers-Duren Harley-Davidson	1999	Revival			4848 S. Peoria Ave.
National Guard Armory	1942	PWA			3902 East 15th St.
National Supply Company/U-Haul	1930	Zigzag			504 E. Archer St.
Newspaper Printing Corporation Office	1947	Streamline	John Cushing		317 S. Boulder Ave.
Oak Lawn Cemetery Entrance Gates	1930	PWA			1133 E. 11th St.
Oklahoma Department of Transportation/Empire Roofing	1940	PWA			1709 E. King Pl.
Oklahoma Natural Gas	1928	Zigzag	Arthur M. Atkinson Frederick V. Kershner	National Register of Historic Places	624 S. Boston Ave.
Page Warehouse	1927–29	Zigzag	Rush, Endacott and Rush Bruce Goff	Demolished 1977	408 E. 13th St.

Appendix

Subject	Date	Style	Architect	Status	Address
Parkcade Parking Garage	1949	Streamline	Henry R. Lohman Construction Co.	Demolished 1973	2nd St. and Boston Ave.
People's State Bank	1941	Streamline		Demolished	2408 E. Admiral Blvd.
Peoria Theater	1948	Deco Moderne			2541 N. Peoria Ave.
Philcade	1931	Zigzag	Smith & Senter Leon B. Senter	National Register of Historic Places	511 S. Boston Ave.
Phoenix Cleaners	1947	Streamline			125 E. 18th St.
Pines Theater (1,200 seats)	1944	Deco Moderne	Corgan & Moore	Demolished 1966	1515 N. Cincinnati Ave.
Public Service Company of Oklahoma	1929	Zigzag	Joseph R. Koberling	National Register of Historic Places	600 S. Main St.
Rex Theater	1948	Deco Moderne remodel due to extensive fire and water damage		Closed	2545 E. Admiral Pl.

Appendix

Subject	Date	Style	Architect	Status	Address
Rialto Theatre (1,200 seats)	1948	Deco Moderne remodel of 1905 Empress Theater	Leon B. Senter	Demolished 1972	17 W. 3rd St.
Riverside Studio/Spotlight Theatre	1929	Zigzag	Bruce Goff	National Register of Historic Places	1381 Riverside Dr.
Royal Theater (800 seats)	1948	Deco Moderne	Hill, Sorey & Hill	Converted to ballroom in mid-1950s Demolished 1991	2637 E. 11th St.
Security Federal/Court of Three Sisters	Remodeled 1937	Streamline	Harry Hamilton Mahler	Demolished 1999	120 W. 4th St.
Service Pipeline Building/ARCO Building	1949	Zigzag and Streamline	Leon B. Senter		520 S. Cincinnati Ave.
Shakespeare Monument	1930s	Zigzag	Adah Robinson Eugene Shonnard		Woodward Park 2435 S. Peoria Ave.

Appendix

Subject	Date	Style	Architect	Status	Address
Silver Castle Restaurants	1936–40	Streamline	Ora Overholzer	Demolished	15th and Peoria Admiral and Lewis 6th and Main 113 E. 10th St. 11th and Indianapolis 3rd and Denver 5600 E. 11th St. 2341 S. Quanah Ave. 3240 E. Admiral Pl.
Skelly Building Addition	1928	Zigzag	Bruce Goff	Demolished	23 W. 4th St.
Skelly Oil Company Station/Homer's Downtown Gulf	1938	Streamline		Demolished	829 S. Denver Ave.
Southwestern Bell Branch Office/Brown School	1933	Streamline			1333 N. Utica Ave.
Southwestern Bell Main Dial Company	1924 modified 1930	Zigzag	Irvin Ray Timlin	National Register of Historic Places	424 S. Detroit Ave.
State Theater (400 seats)	1935	Zigzag (remodel of 1907 Wonderland Theater)	Joseph R. Koberling	Demolished 1973	118 S. Main St.

Appendix

Subject	Date	Style	Architect	Status	Address
Texas Oil Company Service Station	1936	Streamline	Walter Dorwin Teague	Demolished	2501 Southwest Blvd.
T.N. Law Residence	1935	Streamline	William H. Wolaver	Demolished	1841 E. 27th St.
Tower Theater (800 seats)	1930	Streamline	W. Scott Dunne	Demolished 1977	1105 S. Denver Ave.
Town and Country Restaurant	1946	Streamline			3301 S. Peoria Ave.
Tulsa Club	1927	Zigzag	Rush, Endacott and Rush Bruce Goff		115 E. 5th St.
Tulsa Fire Alarm Building	1934	PWA	Frederick V. Kershner	National Register of Historic Places	1010 E. 8th St.
Tulsa Monument Company	1936	Streamline	Harry Hamilton Mahler	National Register of Historic Places	1735 E. 11th St.
Tulsa Municipal Airport	1932	Zigzag	Smith & Senter Frederick V. Kershner	Demolished 1969	6600 E. Apache St.
Tulsa Theater (1,400 seats)	1941	Deco Moderne	Corgan & Moore	Demolished 1973	215 S. Main St.
Tulsa Union Depot	1931	PWA	R.C. Stephens		3 S. Boston Ave.
Union Bus Depot	1935	PWA	Leon B. Senter & Associates Frederick V. Kershner	Demolished 1987	319 S. Cincinnati Ave.
Uptown Theater (800 seats)	1928	Streamline		Demolished 1975	18 S. Main St.

Appendix

Subject	Date	Style	Architect	Status	Address
Warehouse Market	1929	Zigzag	B. Gaylord Noftsger	Façade and tower remain	925 S. Elgin Ave.
Westhope	1929	Zigzag	Frank Lloyd Wright	National Register of Historic Places	3704 S. Birmingham Ave.
Whenthoff Residence	1933	Streamline	Joseph R. Koberling		1142 S. College Ave.
Whitlock's Grocery	1937	Streamline		Demolished	2623 E. 11th St.
Will Rogers High School	1938	PWA	Joseph R. Koberling Leon B. Senter Arthur M. Atkinson	National Register of Historic Places	3909 E. 5th Pl.
Will Rogers Theater (1,000 seats)	1941	Deco Moderne	Jack Corgan	Demolished 1976	4502 E. 11th St.

NOTES

Part I

1. W.S. Hoole Special Collections Library, University of Alabama.
2. McCourt, "When Art Deco Is Really Streamline Moderne."
3. Ibid.
4. Debo, *Tulsa: From Creek Town to Oil Capital*, 14.
5. *Tulsa Tribune*, Tulsa City-County Library, Tulsa, Okla., 1929.
6 . Wallis, *Beyond the Hills*, 51.
7. Ibid., 226–27.
8 . Ibid., 282.
9. Ibid., 374.
10. Goff, "People to People: Grand Age of the Garden."
11. Ibid.
12. Ibid.
13. Jameson, *Bruce Goff*.
14. Iannelli, "Boston Avenue Methodist Episcopal Church," 173–74.
15. Lobbon, "Historic Houses."
16. Bachelder, "Bruce Goff."
17. Mecoy, "Designing Ways."
18. Ibid.

Part II

19. Goble, *Tulsa! Biography of the American City*, 66.
20. 1921 Tulsa Race Riot Commission, *Tulsa Race Riot*, 177.
21. Cole, "Mrs. C.C. Cole's Manuscripts."
22. Junior League of Tulsa, *Tulsa Art Deco*, 82.
23. Everly-Douze, "Design Feud Still Raises Tempest in a Temple."
24. Everett, "Boston Avenue Methodist Episcopal Church South."
25. Warner, "Tulsa Architecture Takes Tour through History."
26. Cole, "Mrs. C.C. Cole's Manuscripts."
27. Welch, *Goff on Goff*, 212.
28. Junior League of Tulsa, *Tulsa Art Deco*, 69.
29. Everly-Douze, *Tulsa Times*, 90.
30. Jackson, "Skaggs Building Missed Out," 2.
31. *Tulsa World* Real Estate Guide.
32. Jackson, "Westhope May Have Roots," A2, cols. 1–5.
33. Ibid.
34. Ibid.
35. Walton, *One Hundred Historic Tulsa Homes*, 161.
36. Ibid., 162.
37. P.J. Lassek, *Tulsa World*, October 8, 1999, 13–16.
38. Wallis, *Way Down Yonder in the Indian Nation*, 133.
39. *Tulsa Union Depot Grand Opening Program*.
40. Adair, "Lung Association of Oklahoma," 1.
41. National Park Service, National Register of Historic Places Official Website.
42. Wagner, *Tulsa Art Deco Experience*, 67.
43. Davis, "Tulsa Monument Company."

Part III

44. Wallis, *Way Down Yonder in the Indian Nation*, 128.
45. Downtown Tulsa Intensive-Level Historic Resources Survey, 35.
46. Ibid., 2.
47. Teaford, "Urban Renewal and Its Aftermath," 443–65. Dr. Teaford points out that originally, Urban Renewal made promises to a large number and variety of interests, but the program fell short of accommodating early supporters. Early on, the critics of big government and the prevailing

planning practices exploited the program's shortcomings to further their own agendas. In later years, the program called into question the use of federal funds to solve urban problems.
48. Tulsa City-County Library, Tulsa and Oklahoma Collection archives, *Tulsa Tribune*, July 23, 1963.
49. Leighty, Smart Growth Tulsa. Smart Growth Tulsa is a nonprofit organization advocating "smart public policy."
50. Ibid., 2.
51. Tulsa Preservation Commission, "Oil Capital Historic District."
52. Krehbiel, "History-Rich Tulsa Buildings," 17.
53. Rhine, "Deco Cityscape," 31.
54. Krehbiel, "History-Rich Tulsa Buildings," 17.
55. Juozapavicius, "Magazine Puts the Spotlight on Tulsa's Art Deco Architecture."
56. Curtis, "Tulsa's Deco Gems."
57. Ibid.
58. *Tulsa World*, September 10, 2014.
59. Ibid.

Part IV

60. Kelsey interview, July 19, 2017.
61. Ibid.
62. Ibid.
63. Wallis, *Way Down Yonder in the Indian Nation*, 134.
64. Ibid., 134–35.
65. Ibid., 134.

BIBLIOGRAPHY

REFERENCES CITED IN TEXT

Libraries and Collections

Goff, Bruce. "People to People: Grand Age of the Garden." AA School of Architecture, Lectures Outline, Library & Collections, Bedford Square, London, 1983-01-01. www.aaschool.ac.uk/VIDEO/lecture.php?ID=2846.

Tulsa City-County Library, Tulsa and Oklahoma collections archives, *Tulsa Tribune*, July 23, 1963, Civic Center [vertical file].

W.S. Hoole Special Collections Library, University of Alabama.

Books

Debo, Angie. *Tulsa: From Creek Town to Oil Capital*. Norman: University of Oklahoma Press, 1943.

Everly-Douze, Susan. *Tulsa Times, a Pictorial History: The Early Years*. Tulsa, OK: Tulsa World Publishing Company, 1988.

Goble, Danney. *Tulsa! Biography of the American City*. Tulsa, OK: Council Oak Books, 1997.

Jameson, David. *Bruce Goff (1904–1982)*. Chicago: ArchiTech Gallery of Architectural Art, 1999–2008.

The Junior League of Tulsa. *Tulsa Art Deco: An Architectural Era 1925–1942*. Tulsa, OK, 1980.

Wagner, Don. *Tulsa Art Deco Experience*. N.p.: Oklahoma Tourist Guides Inc., 2009.

Wallis, Michael. *Beyond the Hills: The Journey of Waite Phillips*. Oklahoma City: Oklahoma Heritage Association, 1995.

———. *Way Down Yonder in the Indian Nation: Writings from America's Heartland*. New York: St. Martin's Press, 1993.

Walton, John Brooks. *One Hundred Historic Tulsa Homes*. Tulsa, OK: Tulsa Foundation for Architecture, 2000.

Welch, Phillip B., ed. *Goff on Goff: Conversations and Lectures*. Norman: University of Oklahoma Press, 1996.

Pamphlet

Tulsa Union Depot Grand Opening Program. Tulsa, OK, May 1983.

Periodicals, Newspapers and Journals

Adair, Lynn. "Lung Association of Oklahoma to Restore Fire Alarm Building for Office." *Tulsa Business Journal*, April 27–May 3, 2001.

Bachelder, Don. "Bruce Goff." *Tulsa World*, February 4, 1973.

Curtis, Wayne. "Tulsa's Deco Gems." *Preservation*, July–August 2008.

Davis, KirLee. "Tulsa Monument Company." *Journal Record*, July 15, 2010.

Everly-Douze, Susan. "Design Feud Still Raises Tempest in a Temple." *Tulsa World*, July 5, 1992.

Iannelli, Alfonso. "The Boston Avenue Methodist Episcopal Church South of Tulsa, Oklahoma." *The Western Architect* 38 (1929).

Jackson, Debbie. "Skaggs Building Missed Out on Renovation Boom." *Tulsa World*, May 1, 2016.

———. "Westhope May Have Roots in Wright's Personal Tragedy." *Tulsa World*, July 23, 2017.

Juozapavicius, Justin. "Magazine Puts the Spotlight on Tulsa's Art Deco Architecture." Associated Press, July 18, 2008.

Krehbiel, Randy. "History-Rich Tulsa Buildings All Have Interesting Stories." *Tulsa World*, April 20, 2001.

Lobbon, Lynette. "Historic Houses." *Sooner Magazine*, Spring 2002.

Mecoy, Laura. "Designing Ways." *Tulsa Tribune*, October 13, 1979.
Pendleton, Scott. "The Piano Player." *This Land*, Spring 2016.
Rhine, Joan. "Deco Cityscape." *Tulsa Cityscape*, April 2001.
Teaford, Jon C. "Urban Renewal and Its Aftermath." *Housing Policy Debate* 11 (2000): 443–65.
Tulsa World Real Estate Guide, December 8, 1991.
Tulsa World, September 10, 2014.
Warner, Elaine. "Tulsa Architecture Takes Tour through History." *Edmond Sun*, May 2, 2014.

Electronic Documents and Sources

Leighty, Bill. Smart Growth Tulsa, October 10, 2013. smartgrowthtulsa.org/comp-plan-victimized-again.
McCourt, Mark J. "When Art Deco Is Really Streamline Moderne, and What It Meant for 1930s Auto Design." Hemmings eDaily, May 29, 2014. www.netfind.com/HemmingsDaily.
National Park Service, National Register of Historic Places Official Website. www.nps.gov/nr/feature/school/2001/Will_Rogers_High_School.htm.
Tulsa Preservation Commission. "Oil Capital Historic District." tulsapreservationcommission.org/commercial_districts/oil-capital-historic-district.

Government Documents

Downtown Tulsa Intensive-Level Historic Resources Survey, prepared for the City of Tulsa by Cathy Ambler, Preservation Consultant, and Rosin Preservation, LLC, October 7, 2009. The Downtown Tulsa Survey was funded in part by the City of Tulsa, the National Trust for Historic Preservation and the Oklahoma State Historic Preservation Office (SHPO).
Everett, Dianna. "Boston Avenue Methodist Episcopal Church South." National Register of Historic Places Registration Form, 1998.
The 1921 Tulsa Race Riot Commission. *Tulsa Race Riot: The Oklahoma Commission to Study the Race Riot of 1921*. February 28, 2001.

Bibliography

Unpublished Manuscript

Cole, Mrs. C.C. "Mrs. C.C. Cole's Manuscripts on the Building of the Boston Avenue Church building, 13th & Boston, Tulsa, Okla., 1929." Excerpt from third manuscript.

Interview

Author interview with Debby Kelsey, July 19, 2017.

Additional References

Books

Capitman, Barbara Baer. *Deco Delights*. New York: E.P. Dutton, 1988.

Dunn, Nina Lane. *Tulsa's Magic Roots*. Tulsa: Oklahoma Book Publishing Company, 1979.

Ford, Beryl, Charles Ford, Rodger Randle and Bob Burke. *Historic Tulsa: An Illustrated History of Tulsa & Tulsa County*. San Antonio, TX: Historical Publishing Network, 2006.

Franks, Kenny A., Paul F. Lambert and Carl N. Tyson. *Early Oklahoma Oil*. College Station: Texas A&M University Press, 1981.

Fred Jones Jr. Museum of Art, *Oklahoma Moderne: Olinka Hrdy*. Norman: University of Oklahoma, 2007.

Fusco, Tony. *Art Deco*. New York: House of Collectibles, 1988.

Harris, Jo Beth. *More Than a Building: The First Century of Boston Avenue Methodist Church*. Tulsa, OK: Council Oak Publishing Company, 1993.

Heide, Robert, and John Gilman. *Popular Art Deco*. New York: Abbeville Press, Inc., 1991.

Saliga, Pauline, and Mary Woolever, eds. *The Architecture of Bruce Goff*. Munich and New York: Art Institute of Chicago and Prestel Verlag, 1995.

Shrimpton, Jayne. *Fashion in the 1920s*. Oxford, UK: Shire Publications LTD, 2013.

Townsend, Jamie. *Memoirs of the Old Lady*. Tulsa, OK: Jamie Townsend, 2015.

Turudich, Daniela. *Art Deco Hair: Hairstyles of the 1920s & 1930s*. Leicester, UK: Streamline Press, 2013.

Wallis, Michael. *Way Down Yonder in the Indian Nation: Writings from America's Heartland.* New York: St. Martin's Press, 1993.

Wolf, Norbert. *Art Deco.* New York: Prestel Verlag, 2013.

Electronic Documents and Sources

Coffey, Roger. "Tulsa's Spotlight Theatre Holds onto Its History." Tulsa, OK: GTR Newspapers, 2015. gtrnews.com/greater-tulsa-reporter/13707/tulsa-s-spotlight-theatre-holds-onto-its-history.

Henderson, Arn. "Goff, Bruce Alonzo." Encyclopedia of Oklahoma History and Culture, accessed October 16, 2015. www.okhistory.org.

Jameson, David. "Bruce Goff (1904–1982)." Chicago: ArchiTech Gallery of Architectural Art, 1999–2008. www.architechgallery.com/arch_info/artists_pages/bruce_goff.html.

Krehbiel, Randy. "Riverside Studio's Hillside Hideaway Has Art Deco Spotlighted." *Tulsa World*, 2001. gtrnews.com/greater-tulsa-reporter/13707/tulsa-s-spotlight-theatre-holds-onto-its-history.

Stockard, Larry. *Tour of Bruce Goff's Riverside Studio–Spotlight Theater.* Oklahoma City, OK: Sooner Spaces, 2014. www.youtube.com/watch?v=KQ502zHq7rA.

INDEX

A

Adah Robinson Residence 32, 33, 45, 116
Aero Exploration Company 89
Allen, Clarence 112, 114
American Association of State Highway Officials 59
American Institute of Architects 98
American Lung Association 81
Anderson, Bob 112
Arkansas River 7, 24, 47, 59, 98, 110
Art Deco 10, 11, 13, 19, 20, 21, 23, 25, 32, 35, 37, 39, 41, 46, 47, 49, 51, 53, 56, 58, 59, 62, 65, 70, 73, 74, 76, 77, 83, 85, 88, 89, 90, 93, 94, 95, 96, 98, 99, 100, 102, 105, 106, 109, 110, 111, 112, 114
Art Institute of Chicago 50
Atkinson, Arthur M. 32, 83, 117, 120, 121, 126
Avery, Cyrus Stevens 10, 59

B

Baily, Ted 101
Baird, M.L. 59
Ballets Russes 19
Ball, Rex 73, 91, 99
Bartlesville 29, 35, 37
Basie, Count 9
Beacon Building 30
Beck, "Boom-Boom" 9
Bergman, Elaine 98
Berkshire Hathaway's BH Media Group 90
Bliss Hotel 96
Blue Devils 9
Blue Dome District 106
BOK Center 105
Bolen, Stew 9
Boone, Ott 90
Boston Avenue Methodist Church 21, 26, 33, 35, 36, 46, 49, 50, 51, 53, 56, 63, 116
Brady Arts District 106
Brooklyn Technical High School 101
Brookside District 106
Byrne and Ryan 56
Byrne, Francis Barry 13, 32, 116

Index

C

Capitman, Barbara Baer 79, 111
Carol Tandy Foundation 83
Central High School 48, 50
Century Geophysical Corporation 33
Century of Progress International Exposition 20
Champion Spark Plug Company 70
Cherry Street District 106
Chicago Academy of Fine Arts 37
Christ the King Church 32, 36, 49, 55, 56, 116
Cities Service Company (CITGO) 61, 62
Cities Service Oil Company Station #8 117
City Veterinary Clinic 23, 33, 117
Civic Center Complex 97
Cole, Audrey 50, 51
Cole, C.C. 50
Cosden Building 25, 28
Cosden, Josh 25, 28
crash of 1929 61, 93
Creek Council Oak 89
Crystal City amusement park 46
Cyrus Avery Centennial Plaza 61, 117

D

Daniel Webster High School 32, 34, 83, 117
Day and Nite Cleaners 34, 117
Day Building 32, 117
Deco District 106, 108, 109
Decopolis 106, 111
DeCort, Amanda 99, 102
Delk, Edward Buehler 25, 30
Dempsey, Jack 9
Diaghilev, Sergei 19
Dickinson, Richard Mansfield 64
Dreamland Theatre 9
Drunkard, The 65
Dunne, W. Scott 117, 125

E

Earhart, Amelia 77
East Coast 101
East Village District 106
Eisenstaedt, Alfred 83
Eleventh Street Bridge 58, 59, 117
Exchange National Bank 25, 27
Exposition Internationale des Arts Décoratifs et Industriels Modernes 13, 19

F

Family & Children's Services 102
Fawcett Building (Stanolind/Amoco) 33, 118
Ferber, Edna 9
Fire Station #7 33, 118
Fire Station #14 33, 118
Forsyth, John Duncan 32, 117, 119
Frank, Grace Lee 39
Frank, John 39
Franklin, William 111, 112, 114
Frankoma Pottery Company 39
Fritz Baily Inc. 83
Fritz, Herb 83, 98, 100, 102

G

G.C. Pride Residence 33, 118
Genet Building (American Airlines Building) 33, 118
Getty, J. Paul 28
GI Bill 93
Gillette-Tyrrell Building (Pythian Building) 70, 118
Glenn, Ida 59
Glenn Pool 7, 24, 90
Goff, Bruce 13, 19, 32, 34, 35, 36, 37, 38, 39, 40, 46, 50, 51, 53, 55, 56, 62, 63, 64, 65, 99, 100, 108, 116, 117, 119, 120, 121, 123, 124, 125
Goff, Corliss Arthur 34
Golden Driller 112

INDEX

Goodwin, Edward Lawrence 90
Gothic Revival 63
Great Depression 11, 28, 41, 61, 64, 68, 69, 78, 93, 100
Greenwood Cultural Center 106
Greenwood Historical District 105
Guaranty Laundry (Page Van Lines) 32, 119

H

Hagler, J.D. 59
Holland Hall School (Boulder on the Park) 64, 89, 119
Home Federal Savings (BOK) 33, 119

I

Indian Chief (Indian Republican) 89
International Council of Art Deco Societies 99

J

Jazz Age 11
John Duncan Forsyth Residence 32, 119

K

Kelsey, Debby 109
Kershner, Frederick 13, 46, 77, 81, 116, 121, 125
Koberling, Joseph R. 33, 46, 50, 83, 88, 99, 116, 117, 118, 119, 120, 122, 124, 126
Kolstad, Karl 83
KOTV News on 6 83
Kress, Red 9
KTUL Radio Station 89
KVOO Radio Station (KJRH Television Studio) 33, 119

L

Leighty, Bill 96
Leon B. Senter & Associates 125
Lorton, Eugene 90

Los Angeles County Museum of Art's Pavilion for Japanese Art 37
Love, Albert Joseph 118

M

Machine Age 20
Magee, Carl 88
Mahler, Harry Hamilton 33, 88, 123, 125
Main Mall 97
Manhattan Construction Company 78, 79
Manifest Destiny 35
Marshall, Leisa 98
Mayo Hotel 10
Mayo, John 25
McFarlin, Robert E. 28
McGay, John B. 33, 88, 119
McGraw, J.J. 25
McIntosh, Lanny 98
McIntyre Field 10
McNulty Park 9, 66
Medical and Dental Arts Building 32, 33, 120
Midwest Equitable Meter 33, 120
Milady's Cleaners (La Maison, Inc.) 73, 121
Miller, Edgar 56
Miss Jackson's 73
Mitchell, Billy 77
moderne 13, 100
Modern Movement 94
Mogul, Mitzi 99
Morrow, Marjorie 112, 114
Murray Jones Murray 101
Myers-Duren Harley-Davidson 105, 121

N

National Trust for Historic Preservation 99
Naylor, Rollie 9
neo-Gothic 25
New Deal 11, 23, 93
Newman, Marty 81, 98, 100, 105

Index

Newspaper Printing Corporation 89, 121
New York Times 98
Nicholson, George 88
Noftsger, B. Gaylord 33, 66, 126

O

Oil Capital of the World 7, 8, 24, 42, 49, 98, 105
Oklahoma Eagle 90
Oklahoma Jazz Hall of Fame 79
Oklahoma Natural Gas 32, 46, 62, 121
Oklahoma State University 101
Oklahoma Sun 90
Olio, the 65
ONEOK 62
ONEOK Field 105

P

Page Warehouse 32, 121
Paige, Sara 49
Parrish, Maxfield 35
Pearl District 106
Pelli, César 105
Philcade 9, 25, 30, 33, 41, 74, 76, 109, 110, 111, 122
Phillips, Frank 74
Phillips, Genevieve Elliott 30, 31, 76
Phillips, Waite 9, 10, 25, 29, 31, 74, 76, 89
Philtower 9, 25, 27, 30, 31, 74
Post, Wiley 77
Prairie style 35, 69
Preservation Oklahoma 102
Price, H.C. 37
Price, Joe 35, 37
Price Tower 37
Public Service Company of Oklahoma 33, 46, 122

R

Rammer Jammer 20
Red Fork 7, 24, 59

Red Wing Hotel 9
Reeds, Ted 98
Rialto Theatre 34, 123
Rice, John A. 51
Riverside Studio (Tulsa Spotlight Theatre) 33, 35, 62, 63, 64, 65, 100, 123
Rives, Mike 89
Roaring Twenties 19, 21
Robinson, Adah 45, 46, 50, 51, 53, 56, 116, 123
Rogers, Will 77, 83, 85
Ross Group 108
Ross, Warren 108
Rowland, Dick 49
Rush, Endacott and Rush 34, 35, 37, 51, 53, 56, 119, 120, 121, 125
Ruth, Babe 9

S

Sand, John 83
Sapulpa 39, 59
Saunders, Edward 33, 70, 118
Schwartz, James 100
Sears, Roebuck and Company 61
Security Federal (Court of Three Sisters) 33, 123
Senter, Leon B. 13, 33, 74, 83, 99, 118, 120, 122, 123, 126
Service Pipeline Building (ARCO Building) 34, 123
Shin'enKan 35, 37
Shriner, Patti Adams 62, 63, 64
Sinclair, Harry 28
Skelly Building Addition 33, 124
Skelly, W.G. 28
Skidmore, Owings & Merrill 101
Smart Growth Tulsa 96
Spartan Aeronautics 112
Spotlighters, the 64
State Theater 33, 124
Stephens, R.C. 78, 125
Streamline 21, 23, 41, 86, 88, 89, 93, 105

Index

Streetsblog 96
Sullivan, Louis 35
Sun Oil 25

T

Tandy, Carol 83
Teague, Walter Dorwin 125
Thompson, Justin 47
T.N. Law Residence 34, 125
Travis Mansion (Tulsa Historical Society) 101
Tulsa Chamber of Commerce 108, 112
Tulsa Club 32, 108, 125
Tulsa Democrat (Tulsa New Era) 90
Tulsa Drillers 105
Tulsa Fire Alarm Building 33, 81, 83, 100, 125
Tulsa Foundation for Architecture 89, 98, 102
Tulsa Historical Society 99, 101
Tulsa International Airport 102
Tulsa International Mayfest 112
Tulsa Monument Company 33, 88, 125
Tulsa Municipal Airport 10, 33, 77, 125
Tulsa Oilers 9
Tulsa Preservation Commission 73, 81, 83, 97, 99, 102
Tulsa Public Schools 109
Tulsa Regional Chamber of Commerce 106
Tulsa Star 90
Tulsa State Fairgrounds 110, 112
Tulsa Tribune, The 26, 90
Tulsa Union Depot 23, 78, 79, 125
Tulsa Urban Renewal Authority 95
Tulsa World 38, 63, 73, 76

U

Union Bus Depot 33, 125
United States Highway System 59
University of Oklahoma 37
Urban Renewal 94, 95, 96, 97, 105
U.S. Highway 66 10

V

Valley of the Kings 11
Veasey, John 89
Veterans Administration 93
Villa Philbrook 9, 30, 31, 77
Villa Philmonte 31
von Eckardt, Wolf 110

W

Wallace, Tom 98
Walter, Frank C. 61, 119
Warehouse Market (Home Depot) 9, 21, 33, 66, 68, 100, 126
West Coast 101
Western League 9
Westhope 34, 69, 70, 90, 126
West, L.G. 88
Williams, Joseph H. 79
Williams, Julius 30
Williamson, George T. 59
Williams Realty Corporation 79
Will Rogers High School 33, 83, 85, 102, 126
Wolaver, William H. 34, 117, 125
World Congress on Art Deco 99
Wright, Frank Lloyd 13, 34, 35, 37, 55, 69, 70, 90, 99, 126

Y

Yancey, Lewis Alonzo 70
Ye Slippe Inn 77

Z

Zeigler, Lee Anne 89, 99, 102

ABOUT THE AUTHOR

Suzanne Fitzgerald Wallis was born in El Paso, Texas, where she attended Loretto Academy. She received her bachelor of arts from Webster University in St. Louis, Missouri, and master's degrees in Spanish and counseling at the University of Missouri in Columbia. After thirteen years in the field of education, she moved to Tulsa, Oklahoma, in 1982 with her husband, Michael Wallis.

In Tulsa, Ms. Wallis moved to the private sector and worked for two years at Brothers and Company Advertising Agency. In 1984, she and her husband joined with Joyce Gideon to form Wallis Gideon Wallis, a public relations firm. When Michael Wallis and Joyce Gideon left the firm, Ms. Wallis reorganized the agency in 1992 as the Wallis Group, a public relations and advertising firm. In 2002, she closed the Wallis Group and founded Project Solutions, a public relations firm limited to special projects for national clients. The firm closed in 2009.

Ms. Wallis has photographed and traveled Route 66 with her husband. They have led tours along America's Main Street for Smithsonian Institution, National Trust for Historic Preservation, Harley-Davidson Motor Co., University Center at Tulsa, Philbrook Museum Friends of Native American Art and Tulsa Foundation for Architecture. They have planned and conducted tours throughout Oklahoma for Tulsa Historical Society.

Following publication of Michael Wallis's book *Route 66: The Mother Road* in 1990, the Wallises coedited *Greetings from the Mother Road: Route 66 Postcards* (St. Martin's Press, 1993). They coauthored *Songdog Diary: 66 Stories from the Road* (Council Oak Books, 1996) and *The Art of Cars* (Chronicle Books, 2006). They worked together on *The Wild West 365* (Abrams, 2011).

ABOUT THE PHOTOGRAPHER/ PHOTOGRAPHY MANAGER

During the past twenty-five years, Sam Joyner has studied with master photographers Bruce Barnbaum, John Sexton, Ruth Bernhardt, Sally Mann, Jerry Eulsman, Howard Bond, Paul Caponigro, George Tice, Mark Klett, Linda Connors, Marilyn Bridges and Don Kirby at fourteen study centers, including the Ansel Adams Photography Workshop, Yosemite, California; the Maine Photographic Workshop, Rockport, Maine; and the Oklahoma Arts Institute at Quartz Mountain.

Joyner's work has been juroed into numerous exhibits, receiving Best of Show at the 1995 Lawton Arts for All Festival and jurors' awards at the 1998 and 1999 Tulsa International Mayfest. His work has been seen in three one-man shows at the McMahon Gallery and Leslie Powell Gallery in Lawton and the Capitol Building Gallery in Oklahoma City and in numerous group shows statewide, including the M.A. Doran Gallery and Gilcrease Museum in Tulsa. His photographs have been published in *Nimrod* International Literary Journal.

Joyner is retired as a United States magistrate judge in Tulsa, Oklahoma. He is represented by M.A. Doran Gallery.

> *In spite of things dark and discouraging, the photographer's special challenge is to go beyond the clichés and stereotypes of our overimagined, media-manipulated world and find the evidence of yes—to reveal scenes of awe, wonder and curiosity with honesty—to find the quiet beauty of coherence, rhythm and order. When the camera and the one who winks its eye do their work well, the photograph may go beyond the literal and touch the timeless and universal. Metaphor is often a part of the process. Light, line and form speak of things beyond the subject being photographed.*
>
> —Sam Joyner